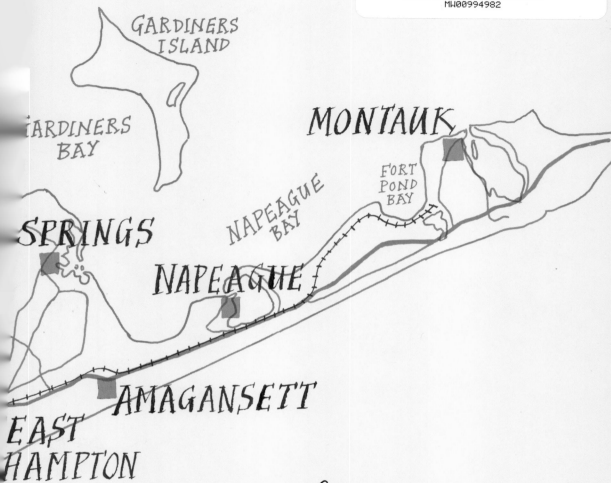

LONG ISLAND

GARDINERS
ISLAND

GARDINERS
BAY

MONTAUK

FORT
POND
BAY

NAPEAGUE
BAY

SPRINGS

NAPEAGUE

AMAGANSETT

EAST
HAMPTON

# The Hamptons

OCEAN

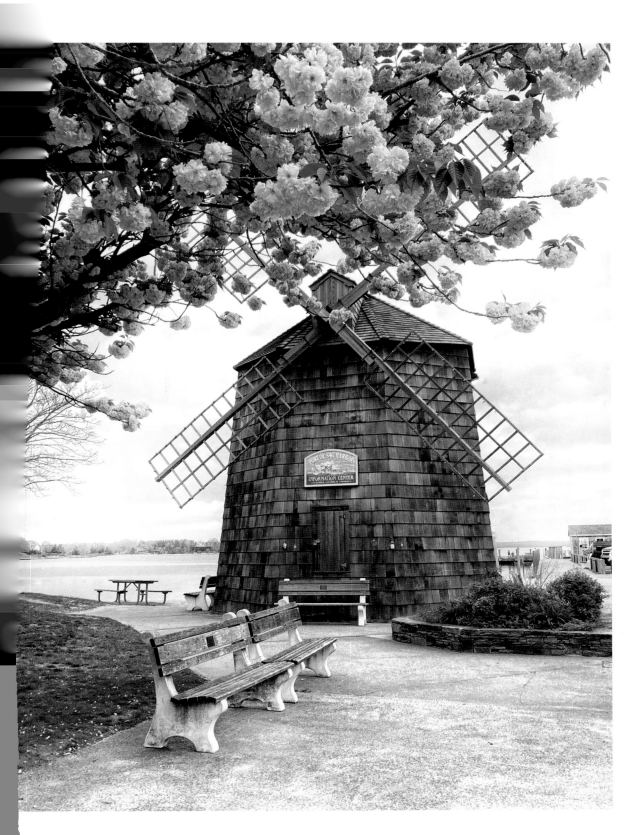

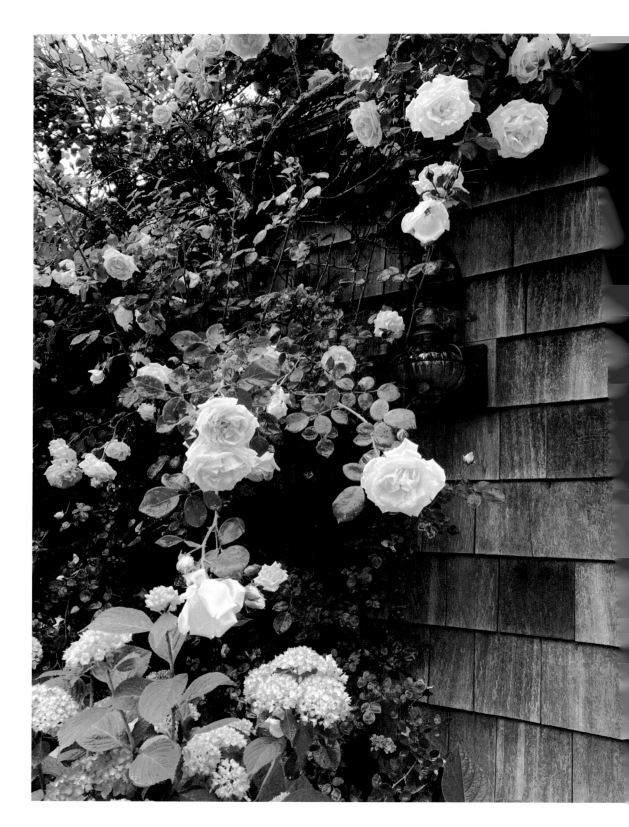

# Walk With Me

# HAMPTONS

THE BEAUTY OF THE HAMPTONS THROUGH THE LENS OF

## SUSAN KAUFMAN

ABRAMS IMAGE, NEW YORK

# Contents

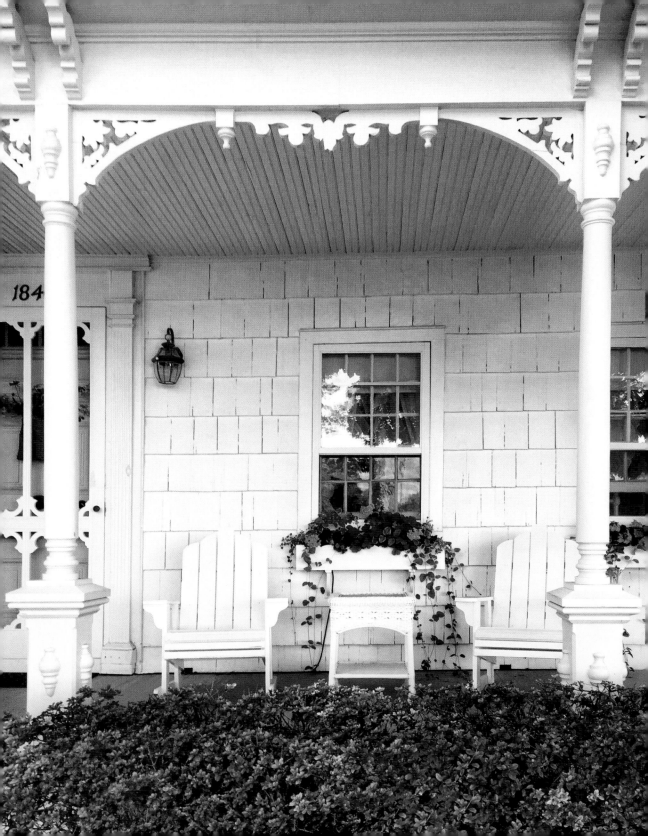

# Introduction

Simply mention the Hamptons, and images of a glamorous summertime playground for the rich and famous with megamansions, walls of manicured hedges, beautiful beaches, and a star-studded social scene usually come to mind. But it's a mistake to think that's all there is to Long Island's celebrated South Fork. Each village and hamlet within the approximately thirty-four-mile stretch, from elegant Southampton (the original Hampton) to laid-back Montauk on the easternmost tip, has its own unique character. And while the Hamptons can indeed be glamorous—celebrity sightings, luxury cars, and fashionable galas abound during the peak summer season—there is another side of the East End that is more down-to-earth, and magical in every season.

I first fell in love with the Hamptons the summer I turned eight years old. I remember driving with my family along Montauk Highway (Route 27) passing the potato fields and duck farms in Sagaponack and Water Mill (now long gone), and rows of cornfields and quaint farmhouses in Wainscott (still around), on our way to my aunt and uncle's East Hampton house. Somehow, I knew I was in a special place. Their lovely little cottage, within walking distance of Main Beach, was in a dream location. After that first visit, I would go on to spend many more happy summer days there: bodysurfing with my brothers in the Atlantic Ocean, eating locally grown corn on the cob, and soaking up the sun and fresh sea air. But what enchanted me the most during my yearly visits were the sprawling, classic, shingle-style summer "cottages," the lush green lawns punctuated with vibrant Nikko Blue hydrangeas, and the majestic old beech trees I would see on my daily walks.

During those idyllic summer days, I never imagined that years later I, too, would own a little slice of heaven out east. On a Labor Day weekend twenty-seven years ago, my husband and I made a spur-of-the-moment decision to take the two-and-a-half-hour drive from New York City to

**OPPOSITE:** An all-white porch with classic Adirondack chairs at the landmarked Conklin House (ca. 1840) on Wainscott Main Street

the Hamptons—and I'm so glad we did. We ended up falling in love with a charming, historic cottage (ca. 1890) in the quiet hamlet of Amagansett, and three weeks later we bought it!

Since then, I've had the luxury of spending time out east year-round. As much as I love the long days of summer—not to mention the chance to escape the city heat—I sigh with relief when the crowds finally disappear and the offseason begins. (Locals jokingly refer to the day after Labor Day as "Tumbleweed Tuesday.") I've also had time to discover so many special spots beyond Amagansett and my old East Hampton stomping grounds. Sag Harbor, a former whaling port, was a revelation when I first saw it, so many eighteenth- and nineteenth-century architectural gems in one very walkable little town. Louse Point Beach in Springs has become a favorite spot for watching spectacular sunsets over Napeague Bay, and strolling along Wainscott's picturesque Main Street, with its rural atmosphere, always feels like stepping back to a simpler time.

This is the Hamptons that I've grown to know and love and want to celebrate in *Walk With Me: Hamptons*. I've always been drawn to the area's rich history and natural beauty: roadside farm stands filled with fresh produce and flowers; quaint cottages; centuries-old windmills; classic shingle-style houses; historic inns; fields of wildflowers; hydrangea-filled gardens; cornfields; and of course, the beautiful beaches.

And while most of the photos in this book were taken from my walks along the village sidewalks of Amagansett, Sag Harbor, East Hampton, Southampton, Wainscott, and Bridgehampton, many other images were first spotted while driving along scenic roads in Sagaponack, Montauk, Springs, and Napeague. With so much territory to cover, you do need a car! For that reason, you'll find not only some of my favorite walks on each village map, but also my favorite drives.

Whether you're lucky to call the East End home, have fond memories of time spent here, just hope to visit one day, or dream of summer days lounging on a wraparound porch, walking on a beautiful beach at dusk, or buying fresh strawberries and sunflowers from a roadside farm stand, I hope that my intimate portrait of the Hamptons' timeless charm will resonate with you.

Susan Kaufman
Amagansett, 2023

**OPPOSITE, CLOCKWISE FROM TOP LEFT:** Tiny cottage on Shore Road in Napeague; Topiaire Flowers' shop front display on Jobs Lane in Southampton; starfish in the window of Sage Street Antiques on Sage Street in Sag Harbor; a barrel of impatiens at the Montauk General Store in Montauk

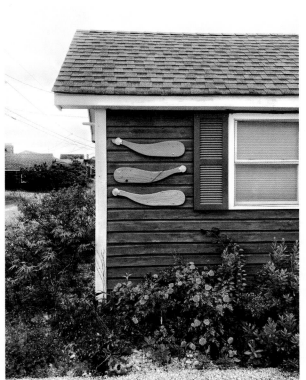
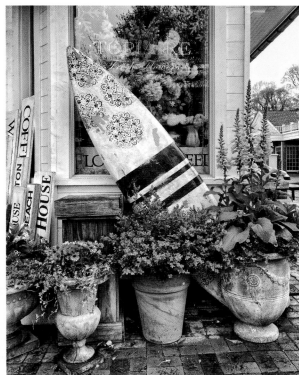

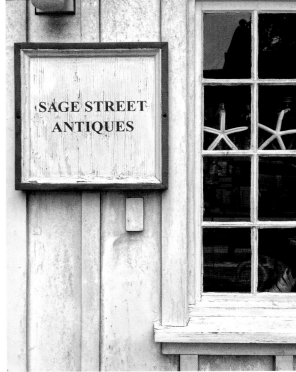

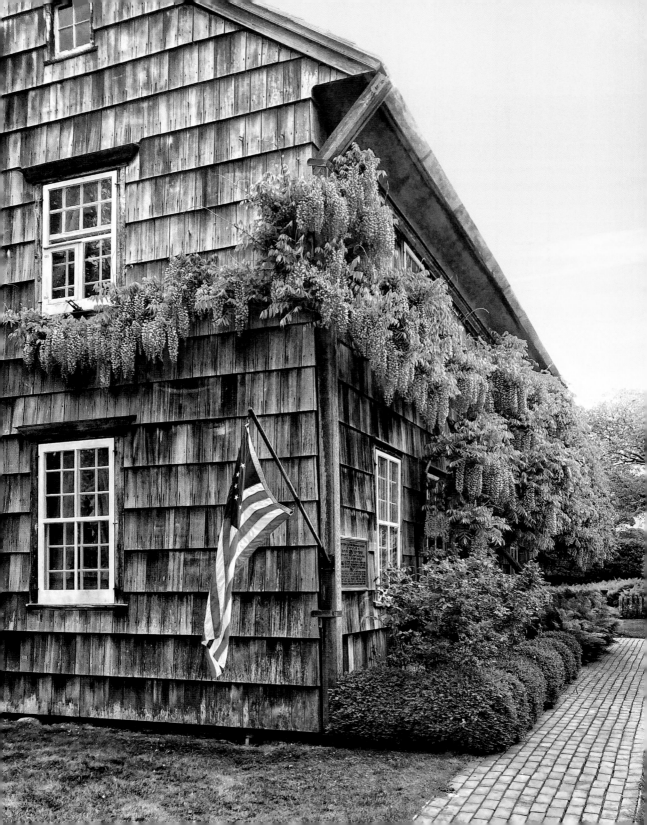

# EAST HAMPTON

East Hampton has been called "America's Most Beautiful Village," and from the moment you pass the stunning White House, a circa-1724 landmark on the corner of Woods Lane, and turn left onto Main Street, you can see why. From the picturesque Town Pond on the village's green (originally used as a watering hole for livestock when East Hampton was founded by English settlers in 1648) to the iconic Hook Windmill, a walk along East Hampton's Main Street delivers a wealth of historically significant buildings. Mulford Farm Museum, an intact colonial farmstead from the early 1700s (and one of my favorite places to photograph); two eighteenth-century windmills; a three-hundred-year-old cemetery; and the Home Sweet Home Museum, a perfectly preserved early 1700s saltbox (and this book's cover), are just some of the fascinating sights you'll see.

While much of East Hampton's past has been protected (thanks to the efforts of the Ladies Village Improvement Society), change is inevitable. Over the past few decades, local mom-and-pop shops on Main Street and Newtown Lane have been replaced by international designer shops like Chanel, Vuitton, and Prada. Parades of luxury cars like Porsches, Mercedes, Range Rovers, and Ferraris regularly cruise through town—surely the town's puritan founders would disapprove. You can, however, still see an occasional farm tractor roll by, a remnant of its rural past.

What hasn't changed are the pristine beaches that I remember from my childhood summers. My bodysurfing days at Main Beach might be over, but it's still my favorite beach for strolling and admiring the grand old beachfront houses of Lily Pond Lane, one of East Hampton's most scenic lanes. (Further Lane, where Jackie Kennedy spent childhood summers at Lasata, her grandfather's stunning estate, is a favorite drive.)

The windswept beaches, classic colonial charm, and elegant estates have attracted a who's who (Jon Bon Jovi, Beyoncé and Jay-Z, Martha Stewart, Ina Garten, and Jerry Seinfeld, to name a few) to this celebrated jewel of the East End.

**OPPOSITE:** The Home Sweet Home Museum on James Lane—a classic saltbox (ca. 1720) and the home of the song's lyricist, John Howard Payne—is covered in beautiful wisteria blooms in late May.

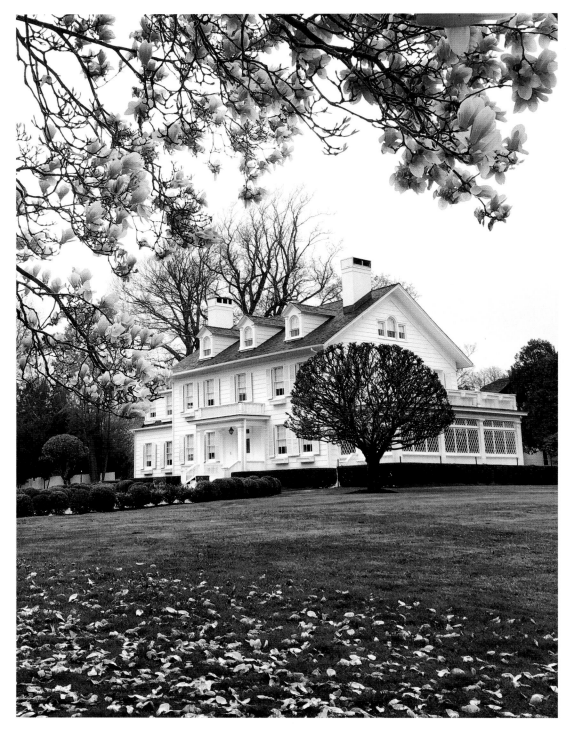

**ABOVE:** Magnolia blossoms at the iconic "White House" (ca. 1724) on the corner of Woods Lane and Main Street  **OPPOSITE:** A tiny, shingled shed on Newtown Lane is hidden behind roses and hydrangeas.

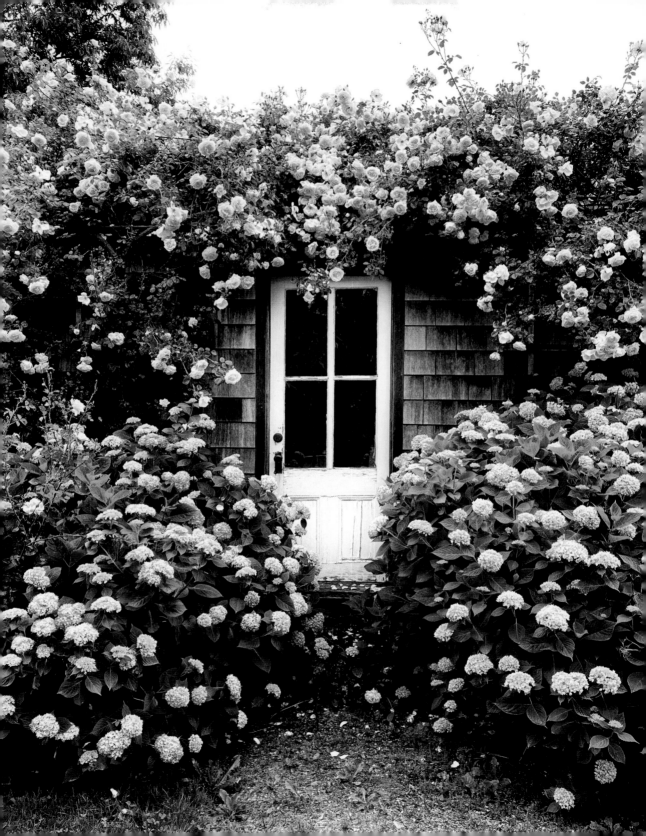

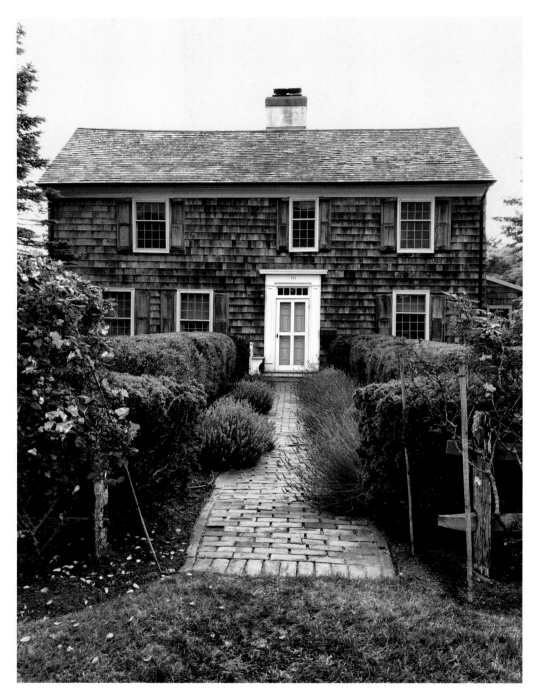

**ABOVE:** This historic house (early 1800s) on Egypt Lane, nicknamed "Rowdy Hall," was once the childhood summer home of First Lady Jacqueline Kennedy Onassis.
**OPPOSITE, CLOCKWISE FROM TOP LEFT:** Mulford Farm's Pantigo Windmill (ca. 1804) and eighteenth century-inspired herb garden on James Lane; Mulford Farmhouse (ca. 1680), a beautifully preserved colonial; Home Sweet Home sign on James Lane; a nineteenth-century Cape Cod cottage on James Lane

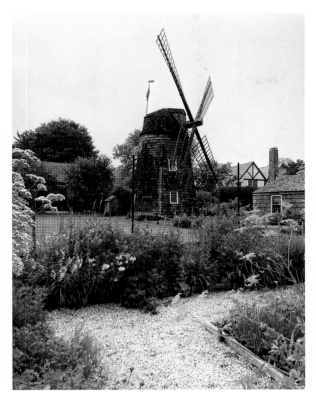
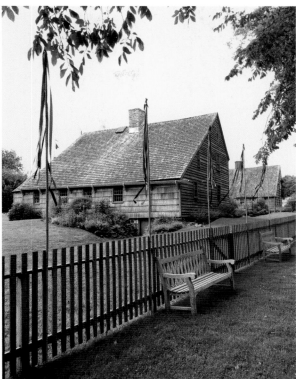
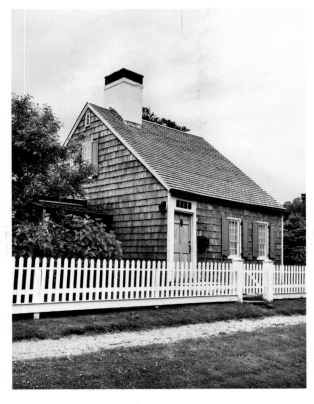
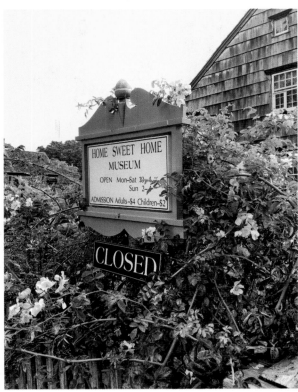

HOME SWEET HOME
MUSEUM
OPEN Mon-Sat 10-4
Sun 2-
ADMISSION Adults-$4 Children-$2

CLOSED

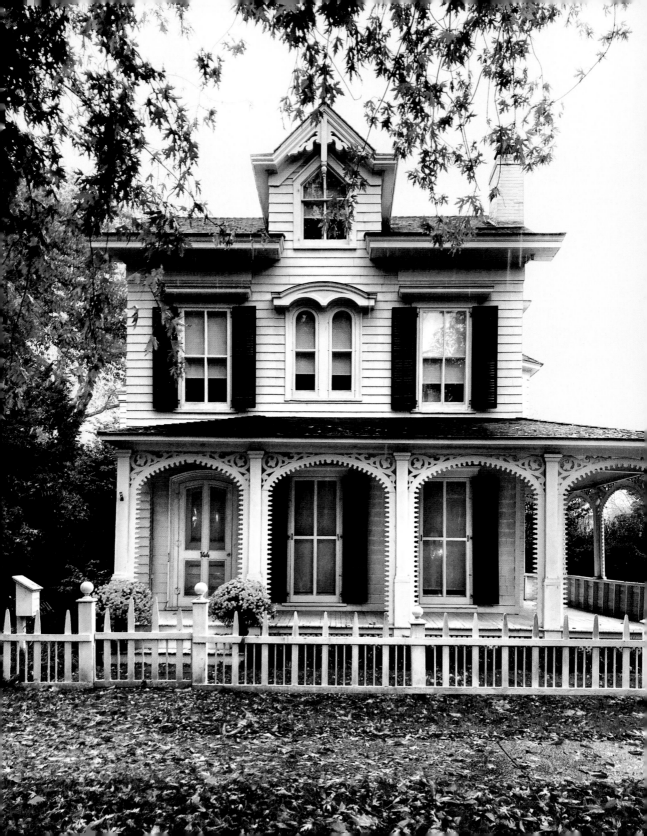

**OPPOSITE:** This ornate Victorian Italianate home (ca. 1870) on Main Street was used as a guest house for aspiring artists in the early 1900s.   **ABOVE:** Golden leaves line Main Street's sidewalk between Davids Lane and Pondview Lane.

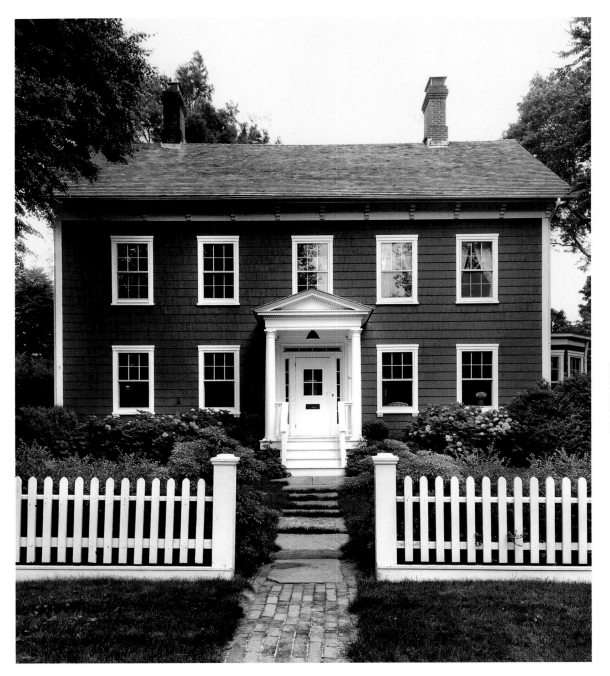

**OPPOSITE:** Antiques for sale in the barn at Mulford Farm's annual East Hampton Antiques and Design Show on James Lane **ABOVE:** With its striking blue exterior and matching blue hydrangeas, this former whaling captain's Greek Revival house (ca. 1860) is a standout on Main Street.

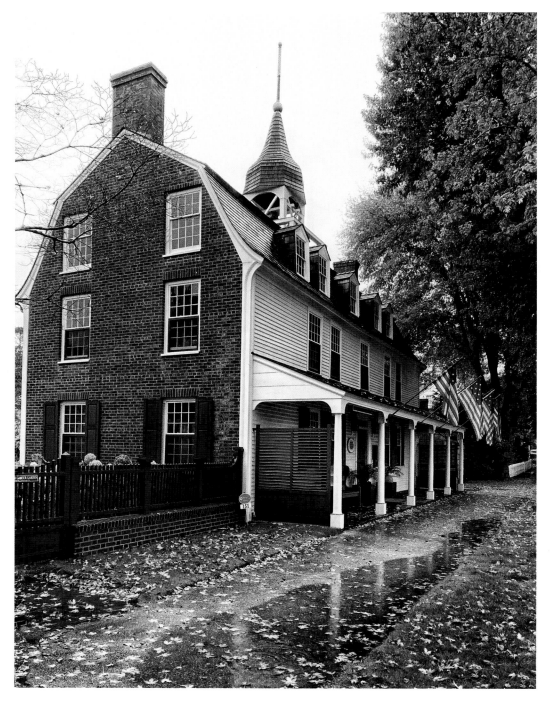

**ABOVE:** The Clinton Academy Museum (ca. 1784) on Main Street was one of New York State's first coeducational prep schools. **OPPOSITE, CLOCKWISE FROM TOP LEFT:** Local newspaper the East Hampton Star's charming office front on Main Street; cute cottage and fall mums on McGuirk Street; BookHampton, a beloved independent bookstore on Main Street; the 1770 House, a classic inn and restaurant on Main Street

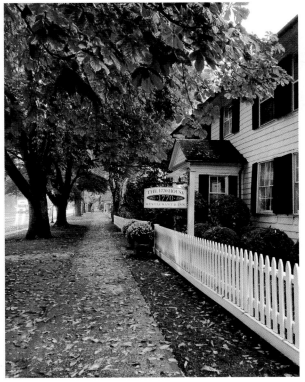

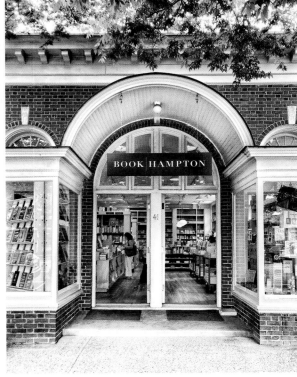

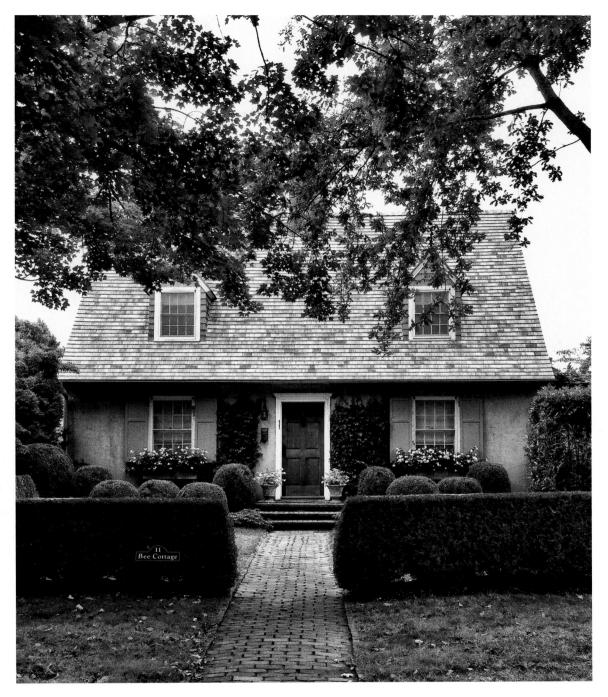

**OPPOSITE:** A beautiful horse chestnut tree graces the village green's Town Pond along James Lane.
**ABOVE:** The storybook "Bee Cottage" on Fithian Lane is a 1920s stucco charmer.

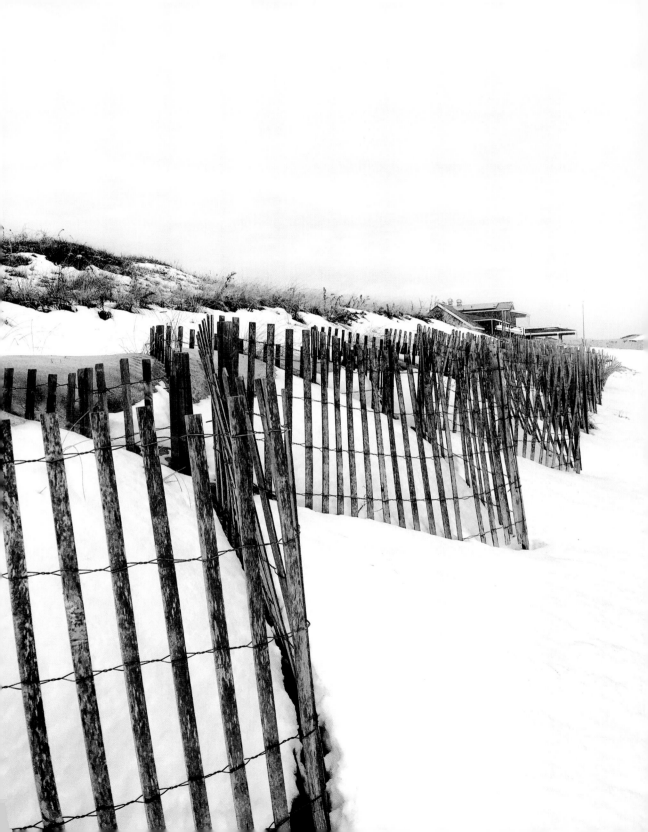

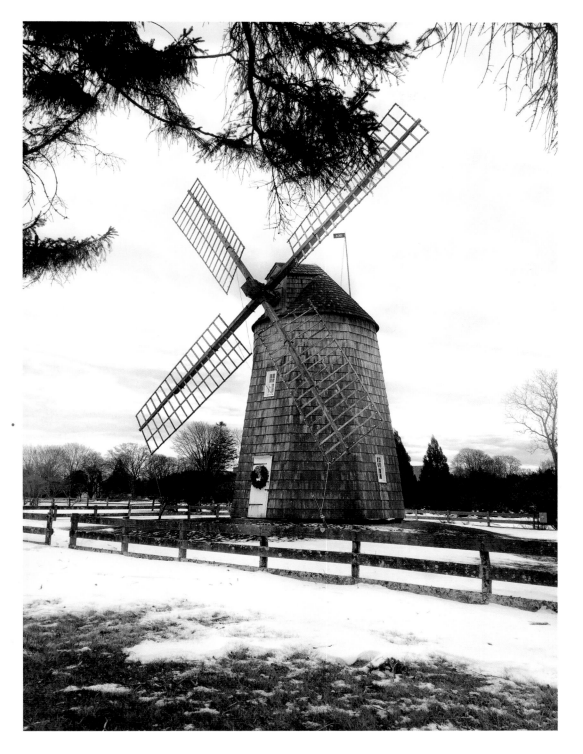

**OPPOSITE:** Main Beach's snow-covered beach and windswept dunes on a cold February day
**ABOVE:** The Gardiner Windmill (ca. 1804) on James Lane is decorated with a simple holiday wreath.

**ABOVE:** The charming 150-year-old Maidstone Hotel on Main Street is all decked out with giant pumpkins and mums. **OPPOSITE, CLOCKWISE FROM TOP LEFT:** A classic farmhouse with fall decorations on Skimhampton Road; a view of the three-hundred-year-old South End Burying Ground from the Maidstone Hotel's front yard; a traditional white house (ca. 1800) on Main Street; the Maidstone Hotel's fun and festive front porch

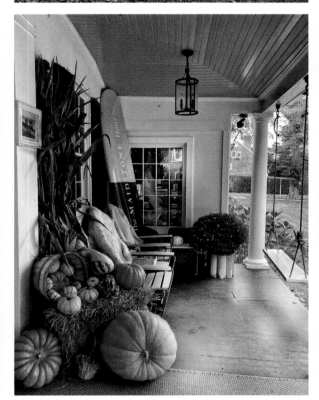
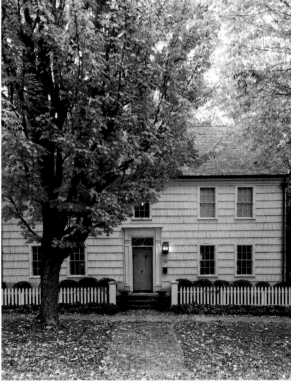

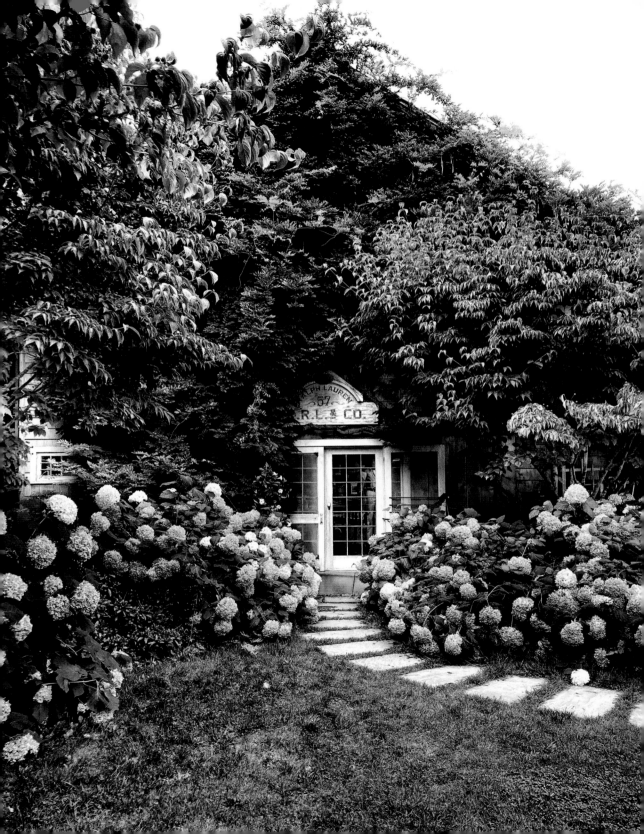

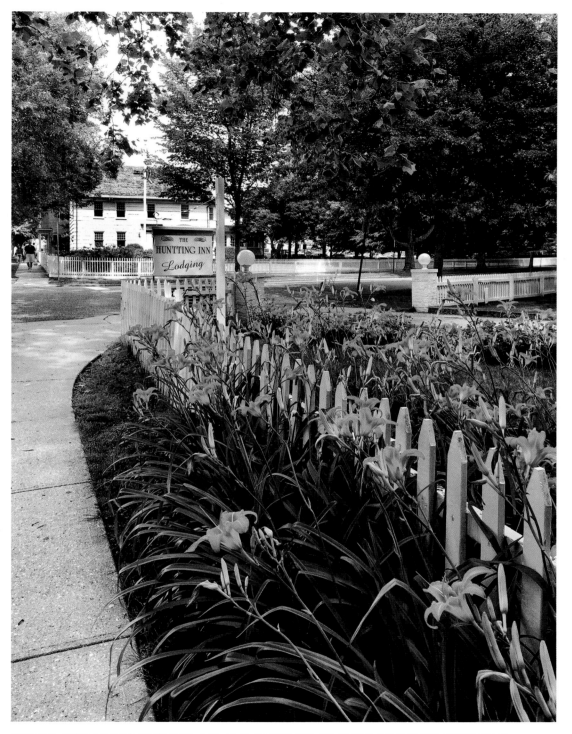

**OPPOSITE:** Ralph Lauren's rustic R.R.L. & Co. shop on Main Street is hidden behind wild wisteria vines and lush hydrangeas. **ABOVE:** Vibrant day lilies in bloom on Main Street by the historic Huntting Inn. The village's town hall, a former eighteenth-century home, can be seen in the background.

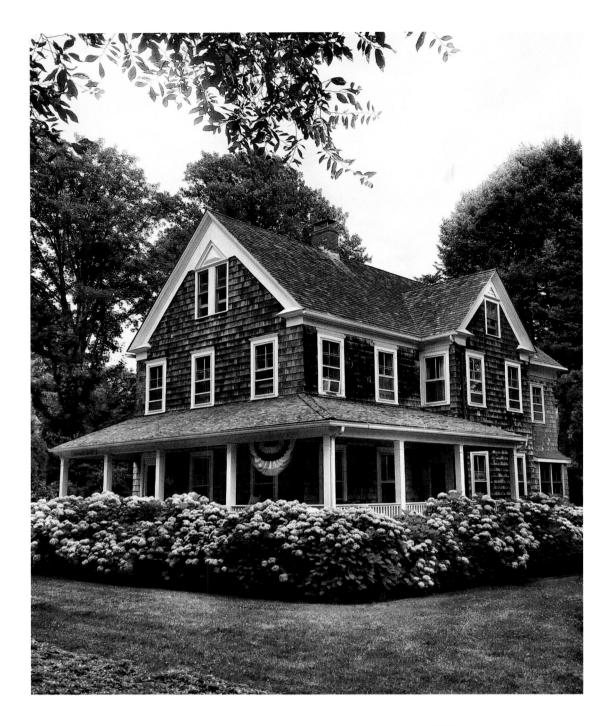

**ABOVE:** A quintessential Hamptons' summer cottage (ca. 1885) with gorgeous blue and purple hydrangeas graces Main Street. **OPPOSITE, CLOCKWISE FROM TOP LEFT:** Fresh summer produce at Round Swamp Farm on Three Mile Harbor Road; a shingle-style summer cottage on Huntting Lane; Ralph Lauren's shop on Main Street is ready for the Fourth of July; a flag is flying on a classic shingled bungalow on Sherrill Road

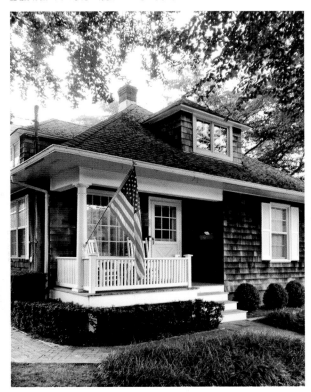
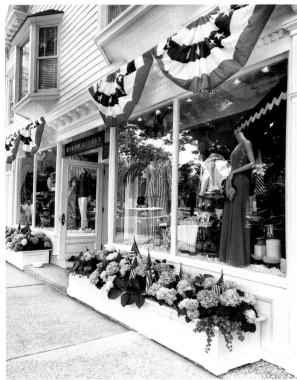

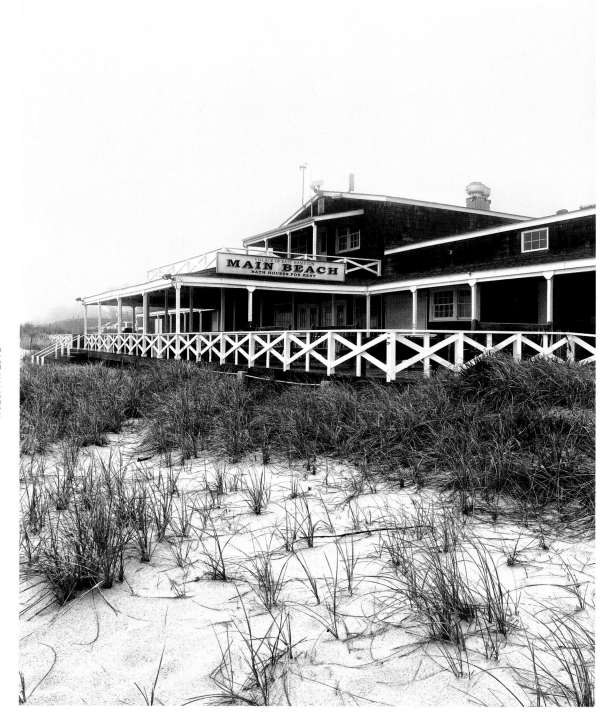

**ABOVE:** Main Beach's beautiful bathhouse and concession stand (ca. 1876) on a foggy spring day

# My Favorite Walks and Drive

EAST HAMPTON

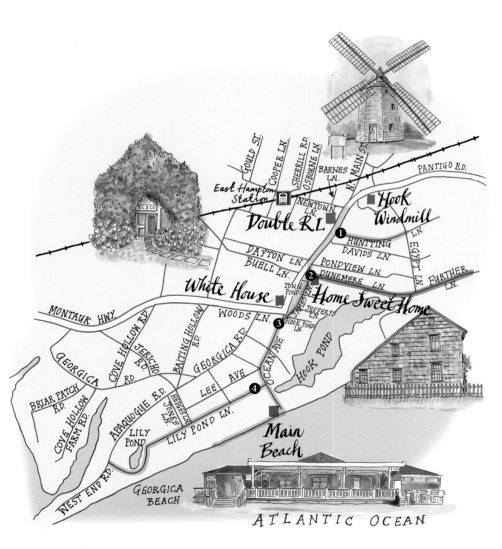

WALKS:

**❶ Huntting Lane**
Lovely turn-of-the century shingled houses on a short walkable block

**❷ Main Street and James Lane**
A favorite walk from the shops, inns, and historic houses on Main Street to James Lane's photogenic Mulford Farm, windmills, and town pond

**❸ Ocean Avenue**
The best walk for seeing the grand summer "cottages" on the way to Main Beach, and a walk on the beach is ideal for admiring beachfront houses.

**❹ Lily Pond Lane**
Majestic trees line this famed block of stately oceanfront homes (including Martha Stewart's former abode).

DRIVE:

**☰ Dunemere Lane to Further Lane**
The lovely drive to Amagansett includes the famed "Lasata" estate and the exclusive Maidstone Club.

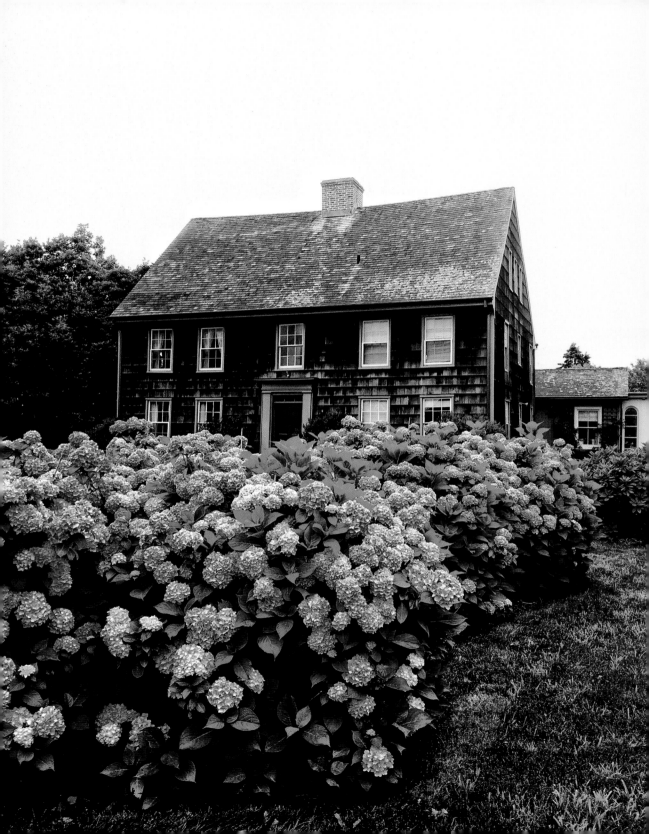

# WAINSCOTT AND SAGAPONACK

Many years ago, I discovered the bucolic rural character of Wainscott when I came out east to style a shoot for a fashion magazine. The photographer I was working with owned a cottage in the heart of Wainscott Main Street. It was next door to the Wainscott Chapel (ca. 1796) and directly across from an open field with an unspoiled (and breathtaking!) view of the Atlantic Ocean. I've been enamored with this tiny hamlet ever since.

Wainscott, established in 1688, was named after an English village in Kent that was immortalized in Charles Dickens's novel *Great Expectations*. Walking down its scenic Main Street—past the landmarked Elisha Conklin House (ca. 1840), the rows of cornfields, and Lisa and Bill's farm stand—is like experiencing a farming community from a bygone era.

Sagaponack is the Shinnecock Indian Nation's word for "land of the big ground nuts." Once, it was filled with sprawling potato fields, but today most of those fertile fields are bursting with megamansions. Fun fact: Sagaponack's zip code has been listed as the most expensive in the United States, including American billionaire Ira Rennert's twenty-nine-bedroom, sixty-three-acre oceanfront estate on Daniels Lane, the largest private home in the country.

My taste runs more toward the picturesque and relatively modest side of Sagaponack: the farmhouses and colonials along Sagg Main Street, and the Sagg General Store and post office. (The two are in the same 1880s building and make up the town's entire "business district.") For natural beauty, the Wölffer Estate Vineyard with its acres of grape vines, and Madoo Conservancy's artfully designed public garden are my go-tos.

I like to think that many of Sagaponack's notable residents past and present—Truman Capote, Kurt Vonnegut, Peter Matthiessen, Caroline Kennedy, and Jimmy Fallon—share my appreciation for this simpler side of Sagg.

**OPPOSITE:** A bounty of blue hydrangeas complement the blue door of the "Topping House" (ca. 1797) on Cemetery Lane in Sagaponack.

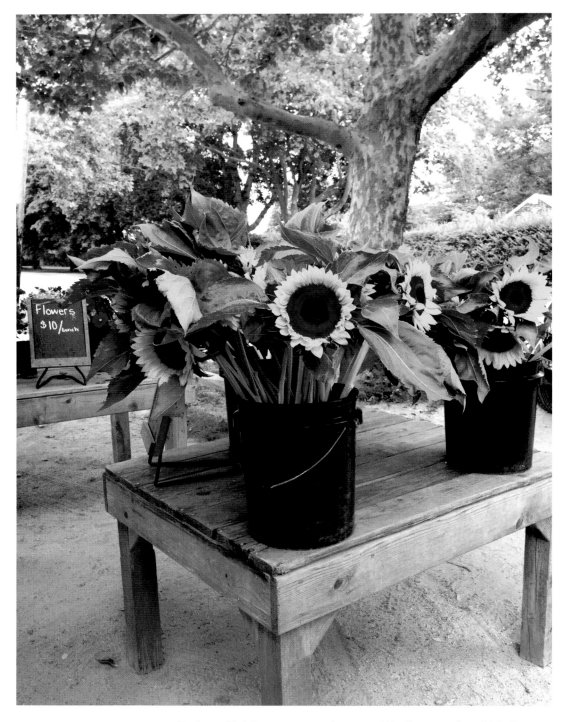

**ABOVE:** Buckets of bright summer sunflowers at Pike Farms on Sagg Main Street in Sagaponack **OPPOSITE:** "Ashley House," a beautiful Federal-style home (ca. 1765), with its striking front yard of daisies, was moved from Fall River, Massachusetts, to Beach Lane in Wainscott in 1984.

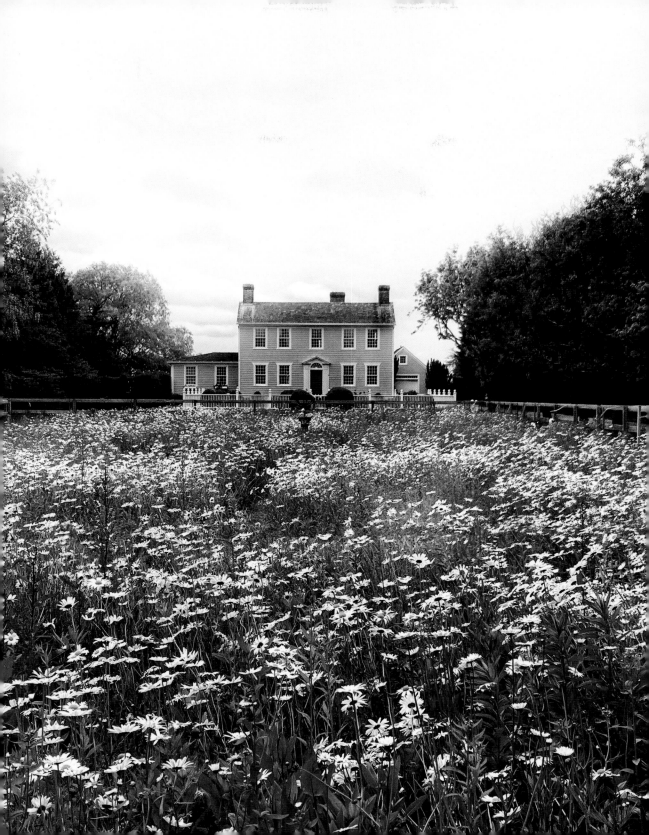

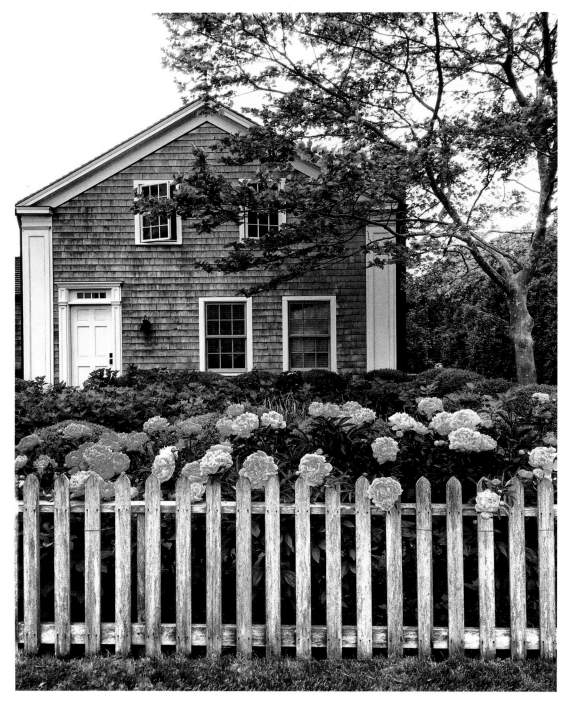

**ABOVE:** A picket fence overflowing with pink peonies and a lovely Greek Revival home (ca. 1842) on Hedges Lane in Sagaponack  **OPPOSITE, CLOCKWISE FROM TOP LEFT:** A sweet farm sign on Sayres Path in Wainscott; a cozy cottage on Beach Lane in Wainscott; Wölffer Estate Vineyard's signature pink wine cart on Montauk Highway in Sagaponack; herbs and berries at Lisa and Bill's / Babinski's Farm Stand on Wainscott Main Street

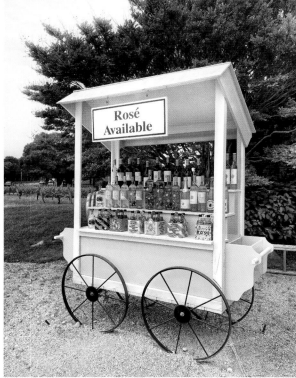

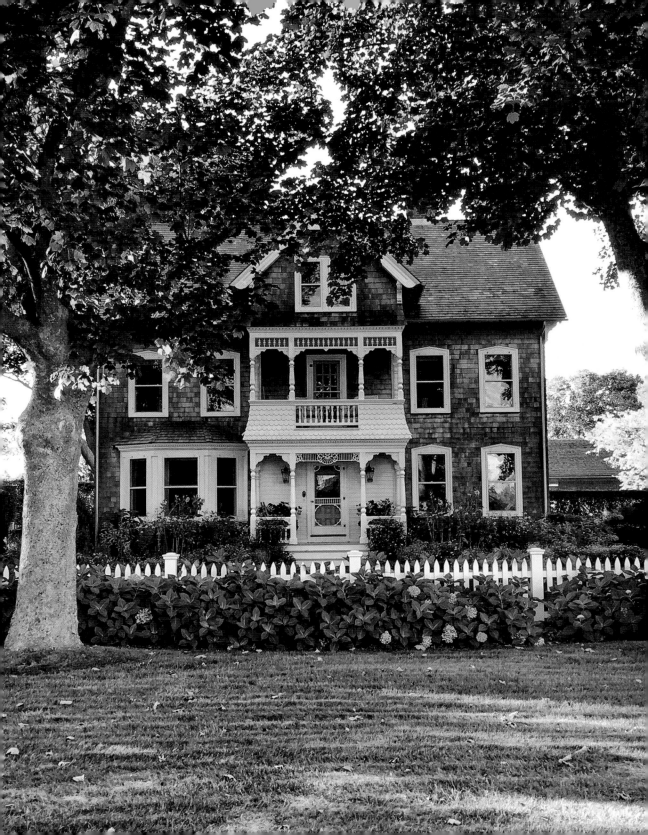

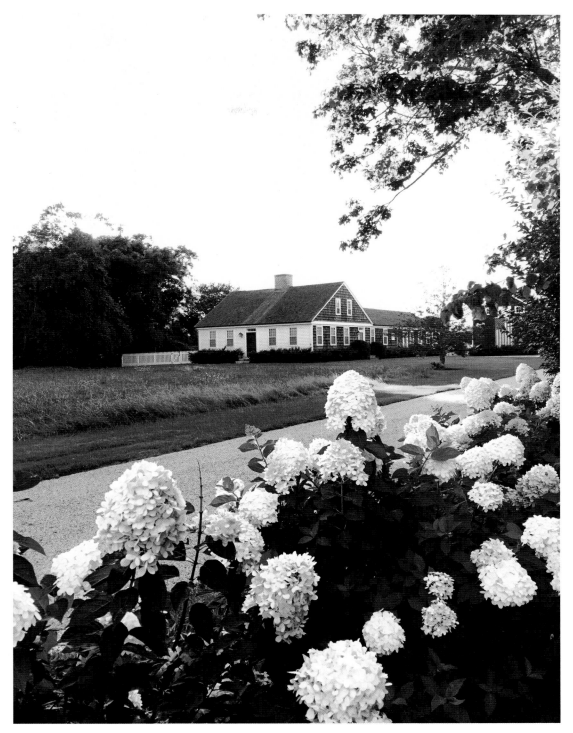

**OPPOSITE:** An exquisite Victorian house (ca. 1895) on Parsonage Lane in Sagaponack
**ABOVE:** Lovely white hydrangeas frame a rambling cottage and barn on Wainscott
Main Street.

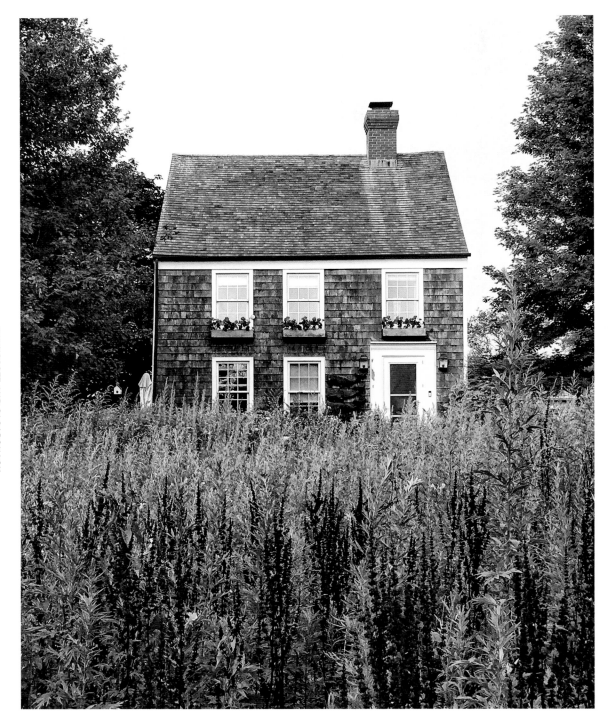

**ABOVE:** Flower-filled window boxes and whale accessories on Five Rod Highway in Wainscott **OPPOSITE, CLOCKWISE FROM TOP LEFT:** Wainscott sign on Main Street; Marilee's Farmstand on Sagg Main Street in Sagaponack; a black lab welcomes visitors on Five Rod Highway in Wainscott; cornfields on Beach Lane in Wainscott

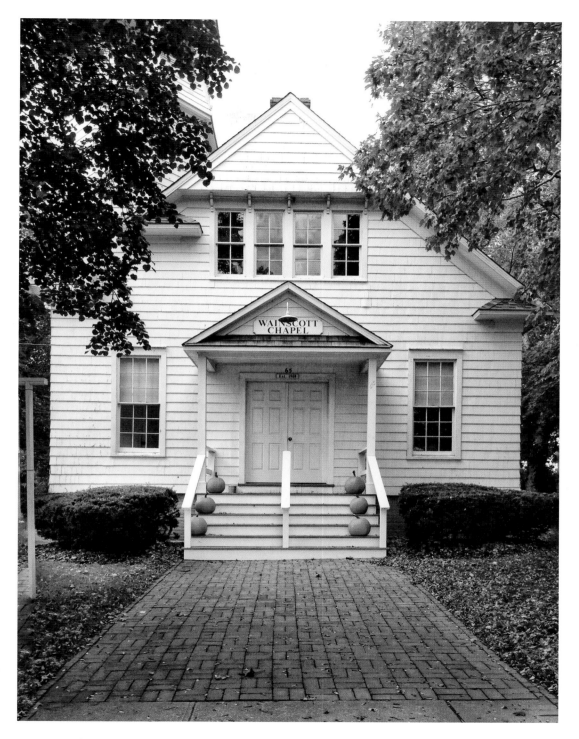

**OPPOSITE:** A fall pumpkin patch on Wainscott Main Street **ABOVE:** The Wainscott Chapel (ca. 1796), a community gathering place on Wainscott Main Street since 1908, was originally a Bridgehampton schoolhouse.

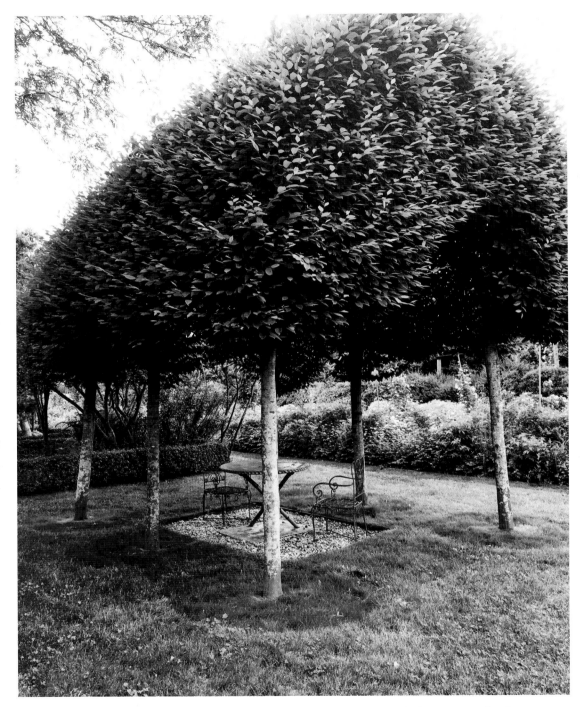

**ABOVE:** A fanciful canopy of hornbeam trees shades a table for two at Madoo Conservancy, a magical two-acre garden in Sagaponack founded by poet Robert Dash. **OPPOSITE, CLOCKWISE FROM TOP LEFT:** A few charming details from Madoo Conservancy's garden: a bright yellow door; curvy garden path; peach and dusty-rose-colored roses; a wisteria-covered cottage and rustic green chairs

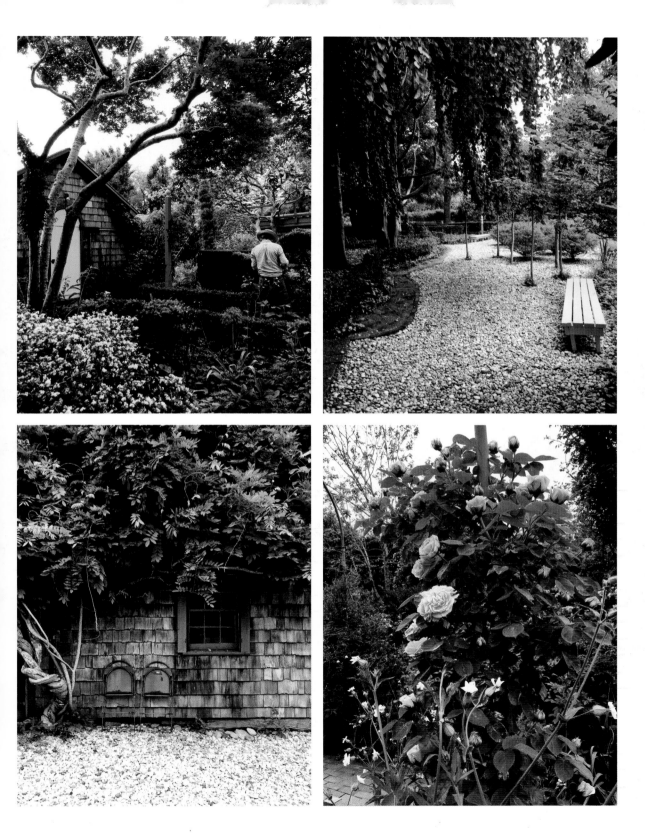

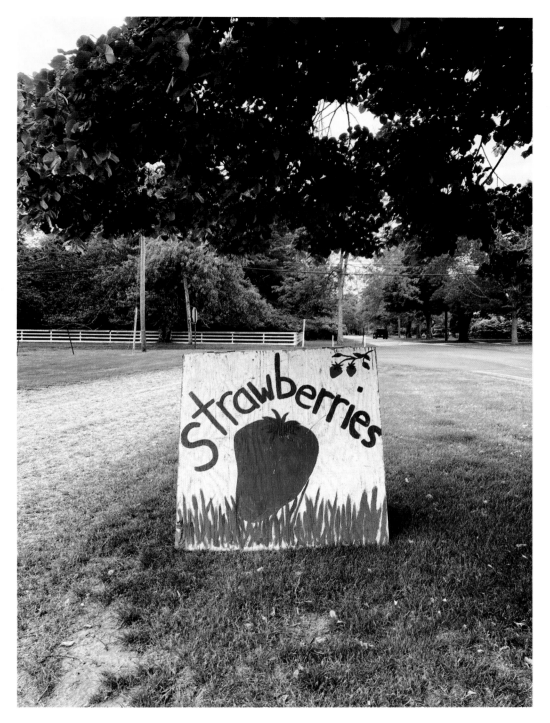

**OPPOSITE:** A sweet gate, an old brick path, and a classic shingled house on Wainscott Main Street are picture-perfect. **ABOVE:** An old-fashioned hand-painted sign on Wainscott Main Street advertises Lisa and Bill's / Babinski's Farm Stand's fresh strawberries.

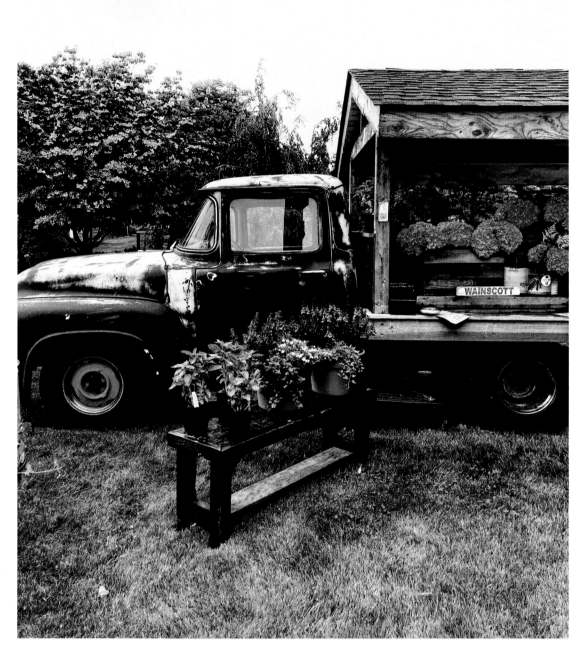

**ABOVE:** A rustic truck is the perfect vehicle for the Osborn Girls' picturesque flower stand on Wainscott Main Street.

# My Favorite Walks and Drive

## WAINSCOTT AND SAGAPONACK

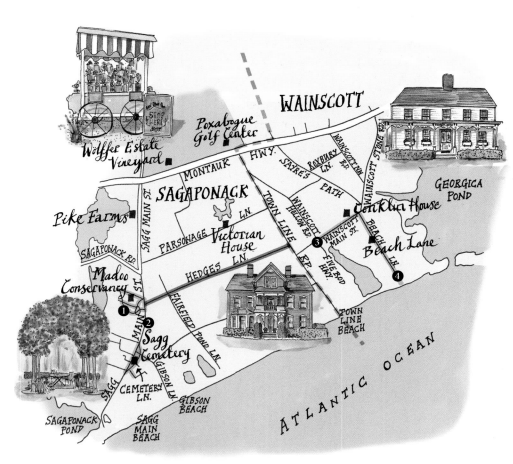

### WALKS:

**❶ Madoo Conservancy**
There's nothing like strolling the grounds of this artistic and captivating garden in spring and summer.

**❷ Sagg Main Street and Cemetery Lane**
A few historic homes all in one quaint area; "Topping House" on Cemetery Lane is so lovely when the hydrangeas are blooming.

**❸ Wainscott Main Street**
A favorite of mine in every season—late summer and fall are especially enchanting.

**❹ Beach Lane**
Cornfields in summer, pumpkins in fall, and a wonderful eclectic mix of houses all year long

### DRIVE:

≡ **Hedges Lane**
From Sagaponack to Wainscott, it's a scenic drive filled with beautiful homes and vistas.

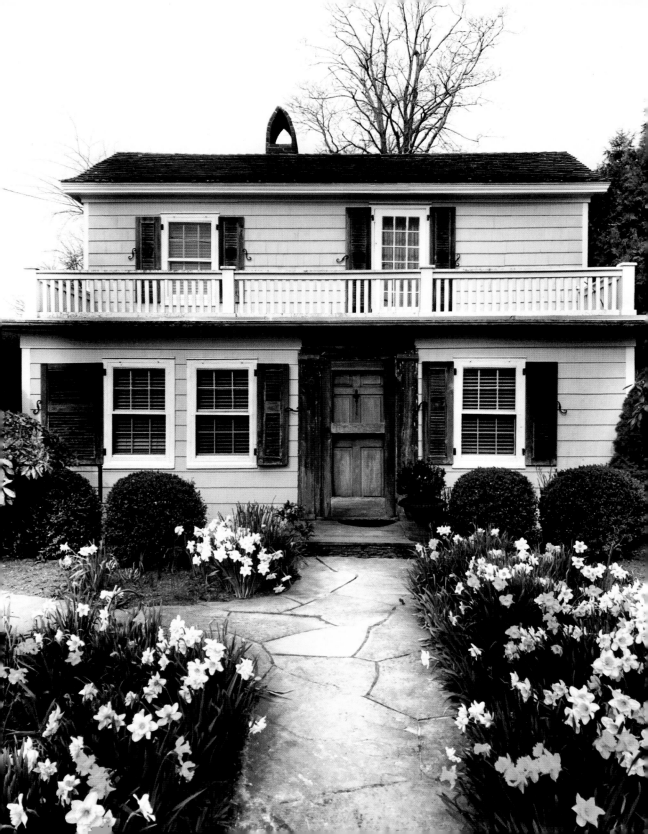

# BRIDGEHAMPTON AND WATER MILL

You can't be considered a true Hamptonite until you've sat at the counter or settled into a booth at Candy Kitchen, the old-school luncheonette in Bridgehampton. It's the place where famous folks like Billy Joel and Sarah Jessica Parker rub shoulders with media moguls, hedge-funders, and local farmers. This iconic coffee shop (it's been going strong since 1925) was even mentioned in the finale of the hit show *Succession*. But Bridgehampton (founded in 1656) has so much more to offer than this popular landmark.

Bridgehampton's bustling Main Street is chock-full of fabulous restaurants, numerous boutiques, and a lovely white steepled church. For horse lovers, the world-class Hampton Classic Horse Show takes place every August on nearby Snake Hollow Road.

While I've spent lots of time in Bridgehampton over the years—antique shopping at Laurin Copen, plant shopping at Marders nursery, celebrating birthdays at Pierre's French Bistro—it was only recently that I discovered the quaint streets and houses surrounding the town center.

And as many times as I've driven through the hamlet of Water Mill (founded in 1644), I've rarely strayed from the main road. I had no idea there was more to Water Mill than my usual landmark sightings along the way: the James Corwith Grist Windmill on the village green (one of eleven surviving windmills on the South Fork, ca. 1800), Duck Walk Vineyards, the Parrish Art Museum, and the private estate Villa Maria.

It's been such fun exploring more of these two neighboring hamlets. I've discovered a working dairy farm on Horsemill Lane in Water Mill, horse farms on acres of rolling green fields along Scuttle Hole Road, and a roadside flower stand filled with buckets of dahlias on Ocean Drive in Bridgehampton—all nice reminders that it's always a good idea to take the road less traveled.

**OPPOSITE:** Cheerful yellow and white daffodils match this yellow antique gem (ca. 1825) on Ocean Road in Bridgehampton.

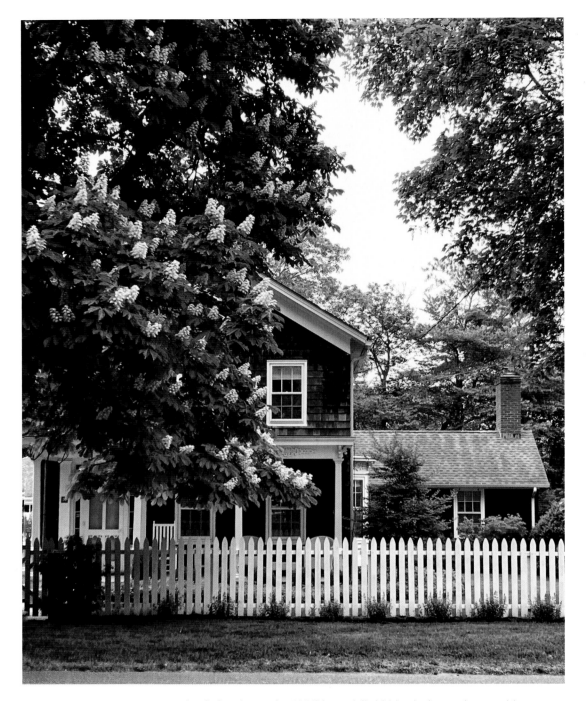

**ABOVE:** A simple farmhouse (ca. 1860) is partially hidden by horse chestnut blooms on Lumber Lane in Bridgehampton. **OPPOSITE, CLOCKWISE FROM TOP LEFT:** Laurin Copen Antiques' roadside display on Montauk Highway in Bridgehampton; Marders garden shop and nursery on Butter Lane in Bridgehampton; Bridgehampton Florist's flower-filled urn on Main Street; horse chestnuts blooming along the Bridgehampton Presbyterian Church's (ca. 1842) driveway on Main Street

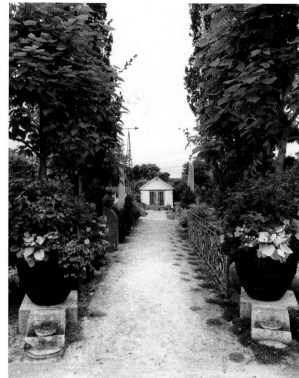

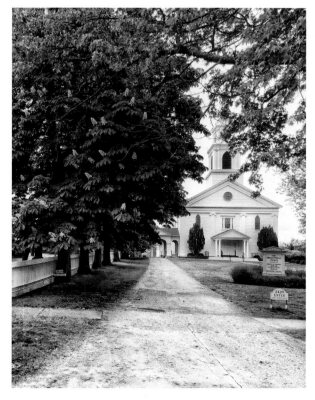

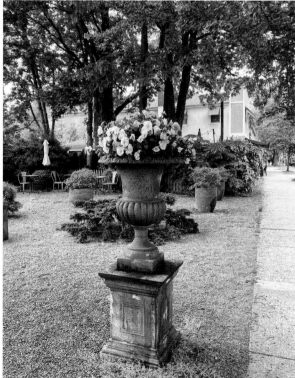

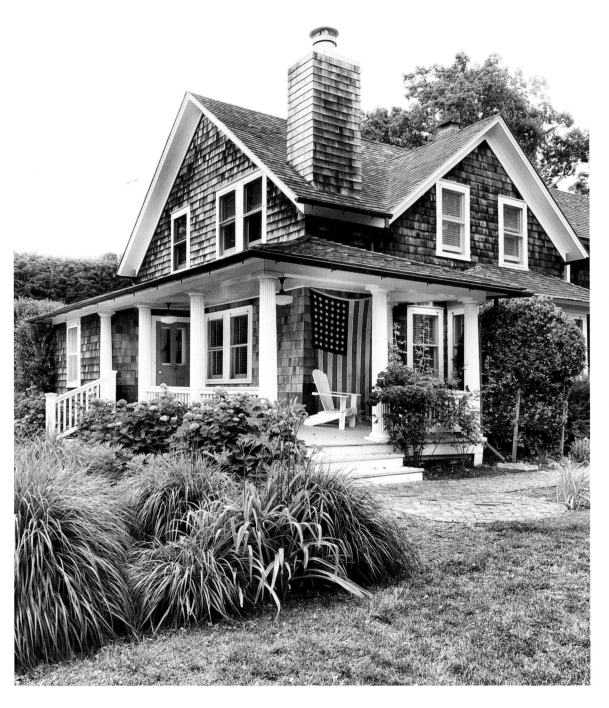

**ABOVE:** A delightful cottage with beautiful summer blooms on Newman Avenue in Bridgehampton is dressed up for the Fourth of July. **OPPOSITE:** The Milk Pail Farm and Orchard's quaint cart display on picturesque Horsemill Lane in Water Mill

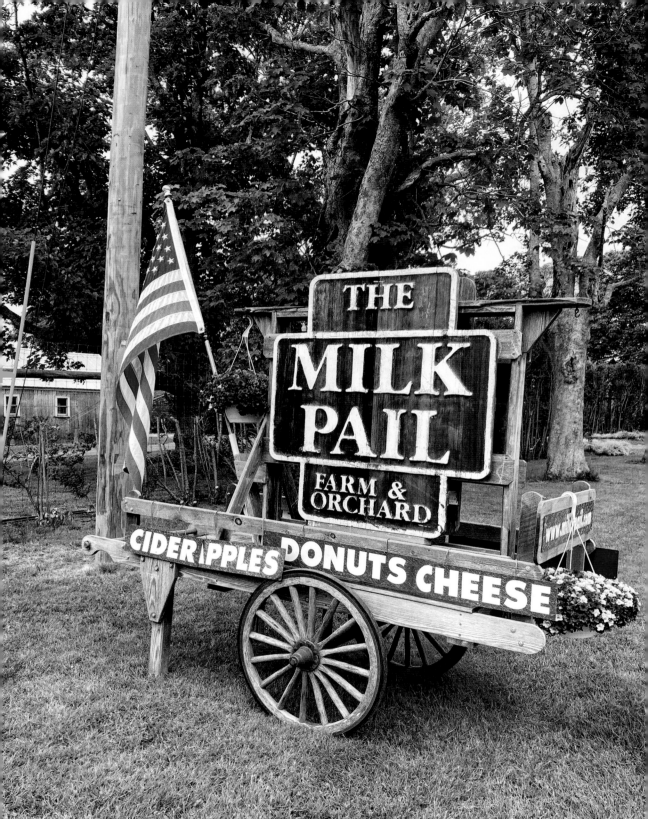

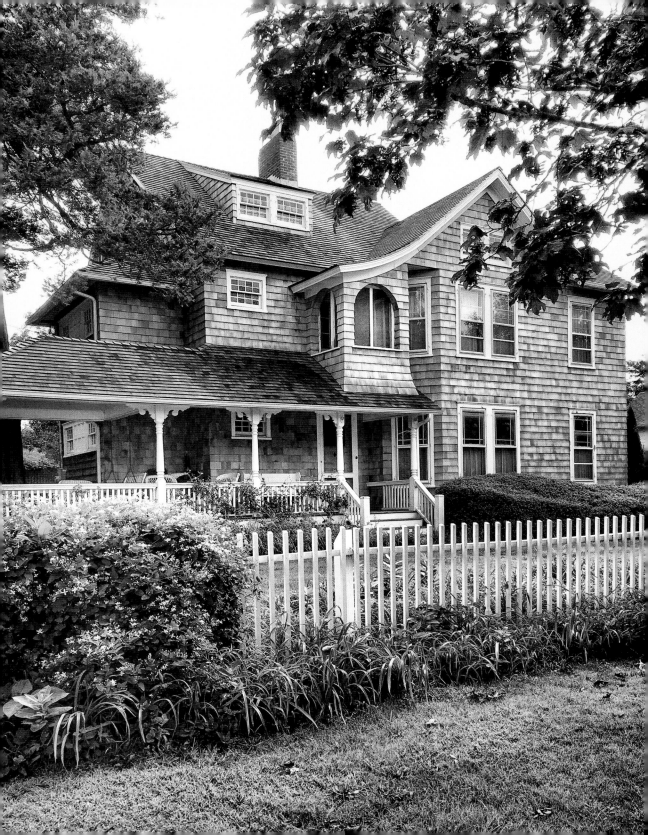

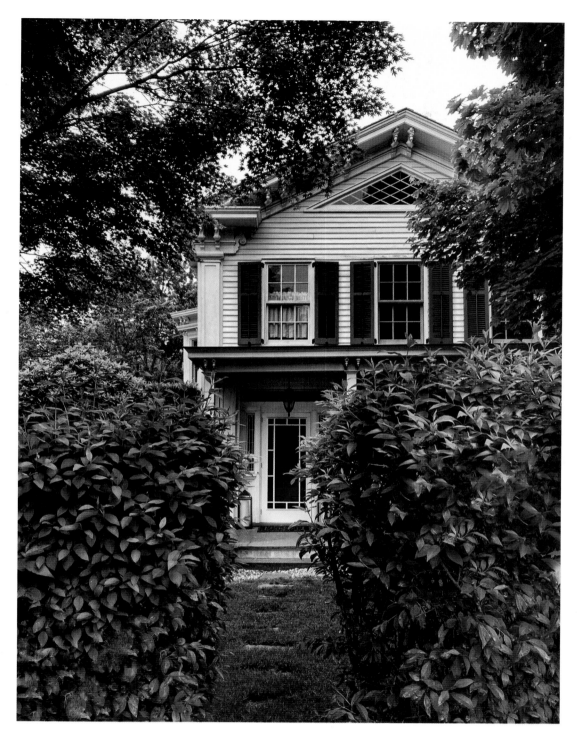

**OPPOSITE:** New shingles on a turn-of-the-century summer cottage (ca. 1910) on Lumber Lane in Bridgehampton **ABOVE:** This handsome Greek Revival on Halsey Street in Bridgehampton displays a nice mix of colors: red door, blue shutters, and yellow exterior.

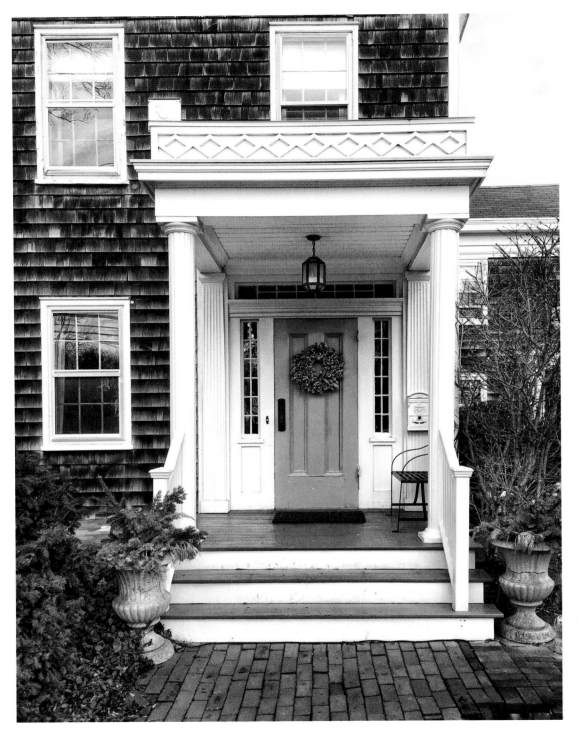

**ABOVE:** The bright orange door of the Bridgehampton Inn and Restaurant on Main Street is a welcome sight on a gray winter day. **OPPOSITE:** A gigantic pumpkin for sale at the Milk Pail Market on Montauk Highway in Water Mill

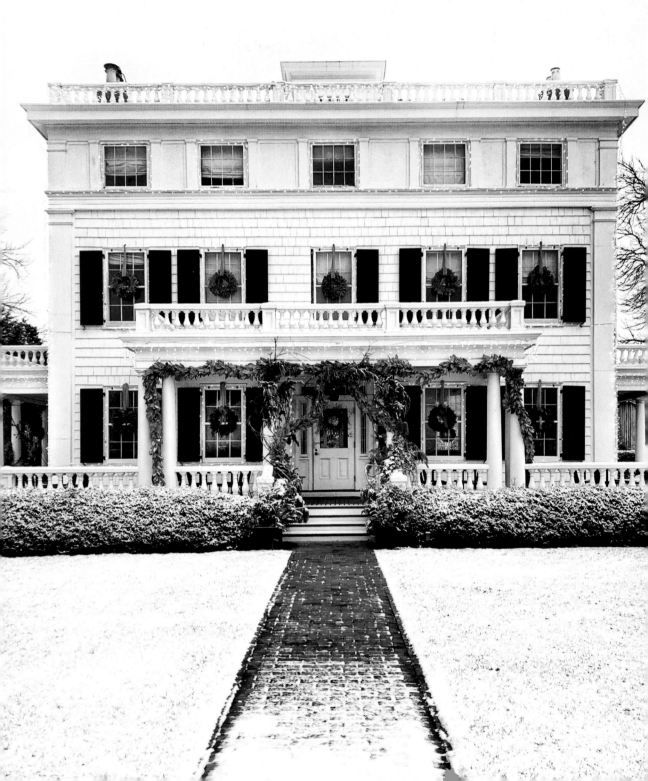

**OPPOSITE:** The elegant Topping Rose House hotel and restaurant, a former private home (ca. 1843) on Main Street in Bridgehampton, is festively adorned for the holidays. **ABOVE:** The Candy Kitchen, an old-school luncheonette on Main Street in Bridgehampton, has been a favorite spot for Hamptonites since it opened in 1925.

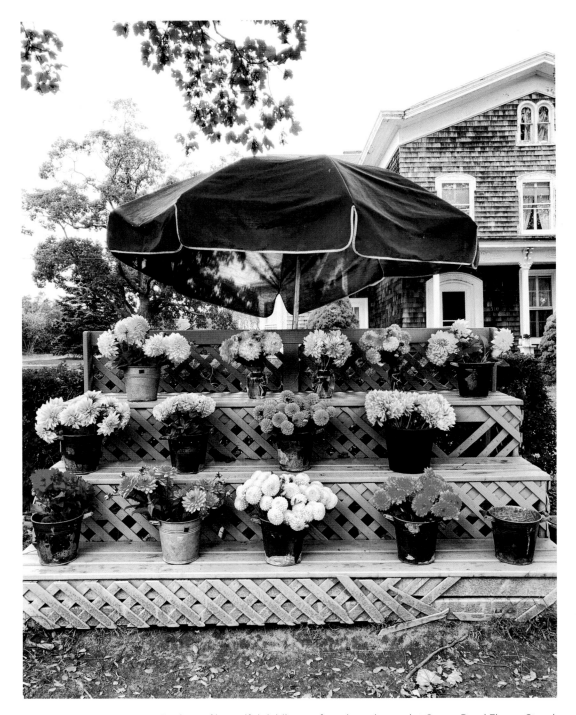

**ABOVE:** Buckets of beautiful dahlias are for sale at the quaint Ocean Road Flower Stand in Bridgehampton. **OPPOSITE, CLOCKWISE FROM TOP LEFT:** Rhododendrons in bloom on Lumber Lane in Bridgehampton; wisteria covers Laurin Copen Antiques on Montauk Highway in Bridgehampton; geraniums on Bridgehampton's Main Street; cherry trees in bloom at the entrance to the Villa Maria estate on Montauk Highway in Water Mill

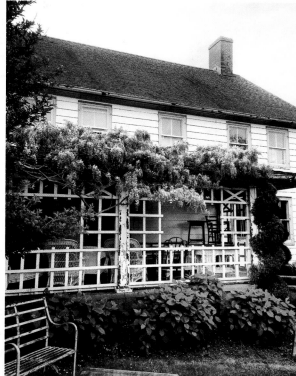
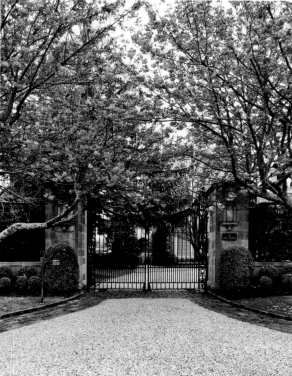

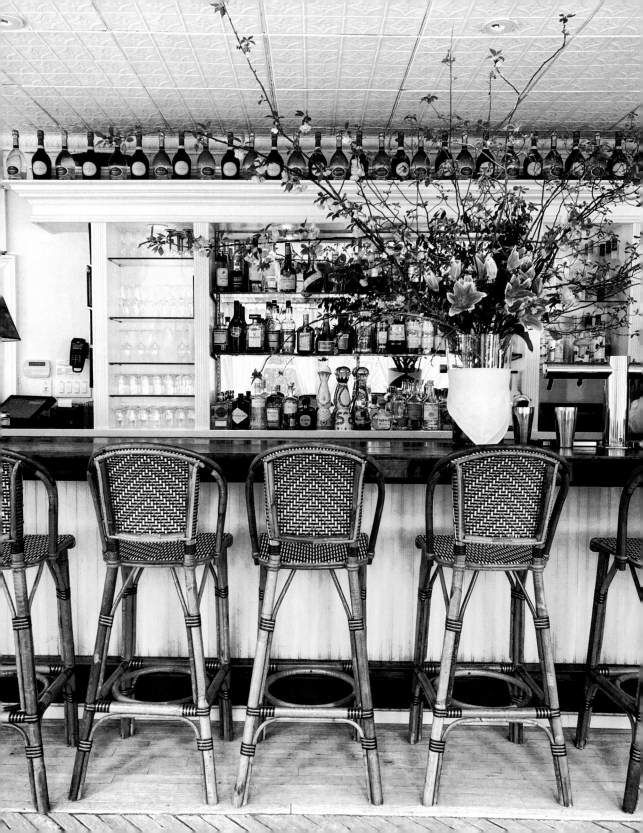

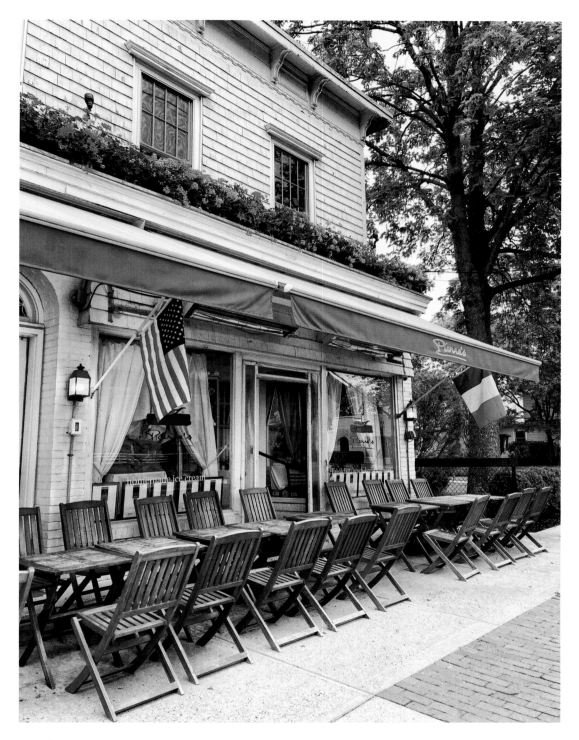

**OPPOSITE:** The sunny yellow bar at Pierre's French restaurant brings a little taste of Provençal style to Bridgehampton. **ABOVE:** Pierre's outdoor dining setup along Main Street is so inviting, especially on balmy summer evenings.

**ABOVE:** An understated white house (ca. 1840) with classic boxwoods on Hull Lane in Bridgehampton is simply chic.

# My Favorite Walks and Drive

BRIDGEHAMPTON AND WATER MILL

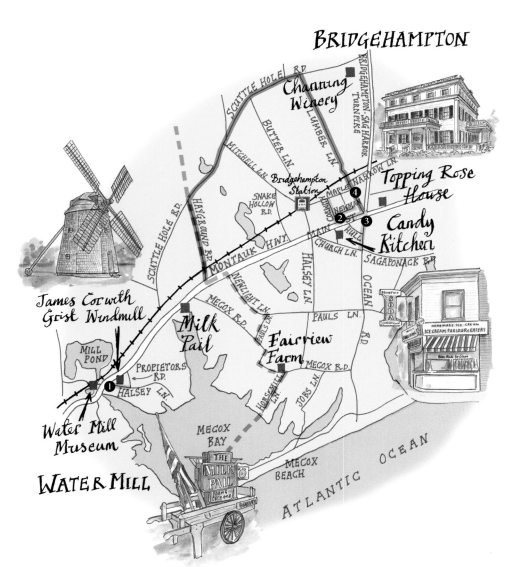

## WALKS:

**❶ Halsey Lane**
It's a short stroll from Water Mill's town green to Halsey Lane's scenic landscapes and lovely homes.

**❷ Newman Avenue**
There are smaller charming houses as well as the Dan Flavin Art Institute on the loop around Corwith and Newman Avenues.

**❸ Ocean Road**
From Main Street to Church Lane, quaint older houses lead to sweeping lawns and grand old mansions.

**❹ Lumber Lane**
Between Main Street and Maple Lane there's a wealth of old summer cottages and farmhouse styles.

## DRIVE:

**≡ Hayground Road**
You pass horse farms and captivating countryside on the ride from Hayground to Scuttle Hole Road and Lumber Lane.

# SAG HARBOR

For quaint small-town charm, there's no place like Sag Harbor. There's even a five-and-dime store still operating on Main Street! This former whaling village is also the Hamptons' most walkable town (no car needed here!), and my favorite place to photograph. (I probably could have done a whole book on Sag Harbor alone.) For anyone who loves older homes as much as I do, discovering the wealth of eighteenth- and nineteenth-century cottages and former sea captains' mansions concentrated within the village's two square miles is like hitting the jackpot. Best of all, they're readily visible from the sidewalk, unlike so many Hamptons' houses that are hidden behind hedges.

Shops and restaurants in Sag Harbor stay open all year long, which is not the case in some of the other Hamptons' hamlets, so there's always a good reason to visit. (A cozy dinner by a roaring fire at the American Hotel is a winter must.) I love wandering the narrow streets packed with close-knit houses (no grand estates here), discovering a small cottage garden bursting with spring flowers on Suffolk Street, or snapping pics of elaborate holiday decorations. Like the West Village, my other favorite neighborhood to shoot, homeowners and shopkeepers here like to go all out with their holiday decor. In the summer, a walk along the pier to check out the vintage sailboats and luxury yachts is always entertaining.

Sag Harbor is also a great place for book lovers—there are three independent bookstores in town, and it also has an impressive literary history. Many renowned writers (and some of my personal favorites) have lived here, including John Steinbeck, E. L. Doctorow, and Colson Whitehead. And the village itself has also been immortalized in *Moby-Dick*, Herman Melville's whaling opus, and in *Sag Harbor*, Whitehead's fictionalized coming-of-age story set in the real-life Black summer community of Azurest. (Whitehead currently owns a summer home in the historic Eastville section.) Not bad for an old whaling town!

**OPPOSITE:** The unexpected color combination—dark blue exterior and green door—makes this 1800s cottage a standout on Suffolk Street.

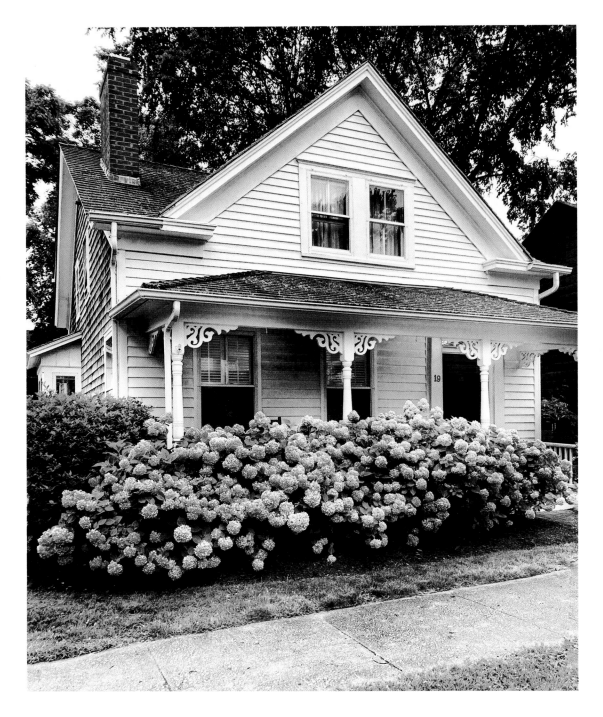

**ABOVE:** A sweet little Victorian cottage on Concord Street is bursting with pink hydrangeas.
**OPPOSITE, CLOCKWISE FROM TOP LEFT:** A stunning nineteenth-century Victorian gingerbread house on Main Street is home to women's concept store Matriark; LoveShackFancy's romantic women's clothing shop on Main Street; Captain's House (ca. 1828) with pink hydrangeas on Suffolk Street; a classic white house with roses on Division Street

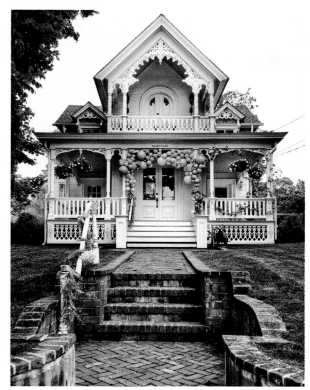
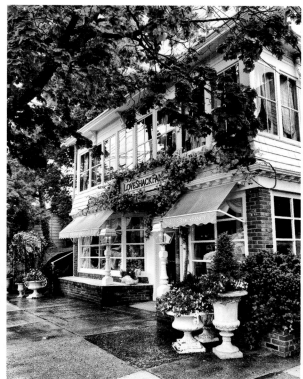
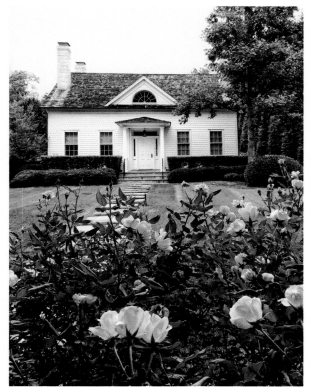
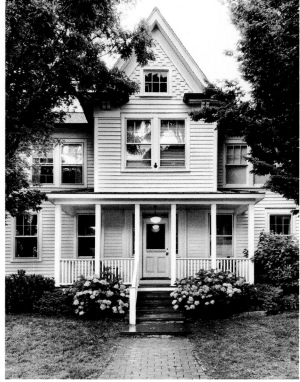

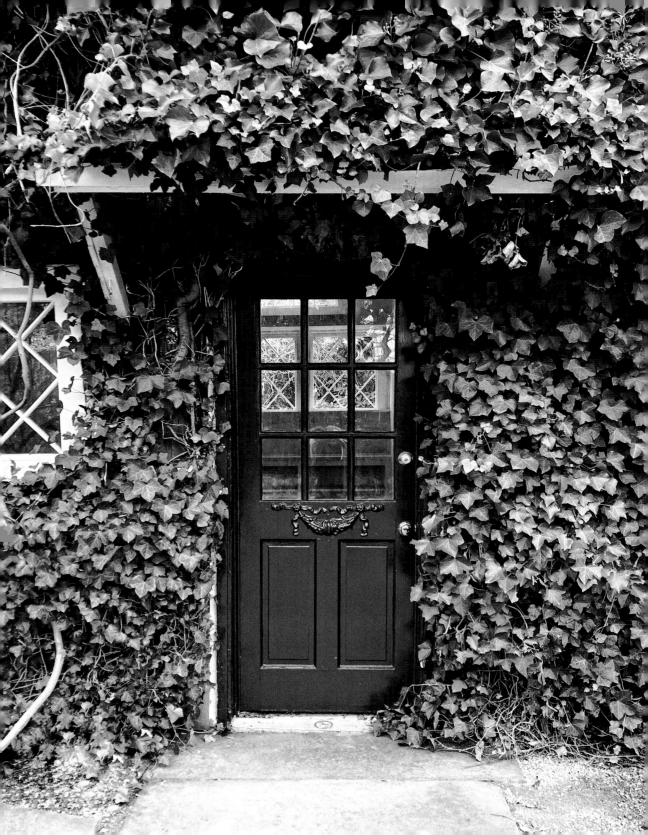

**OPPOSITE:** The 1818 Collective design shop's romantic ivy-covered cottage on Sage Street
**ABOVE:** This historic little jewel on Union Street dating from 1693 is one of the oldest private
homes in the Hamptons.

**ABOVE:** A cheerful house with blue shutters and beachy accessories on Rysam Street
**OPPOSITE, CLOCKWISE FROM TOP LEFT:** A classic sailboat moored in Sag Harbor's marina; the iconic Sag Harbor Cinema on Main Street; the Dockside seafood shack on Long Wharf; Canio's Books, a beloved bookstore on Main Street, holds a marathon reading of Herman Melville's *Moby-Dick* every year

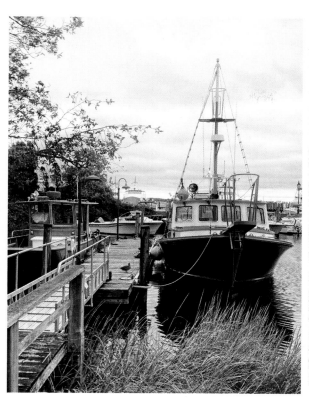
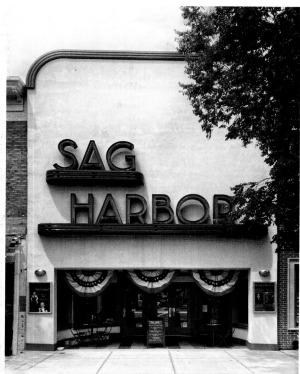

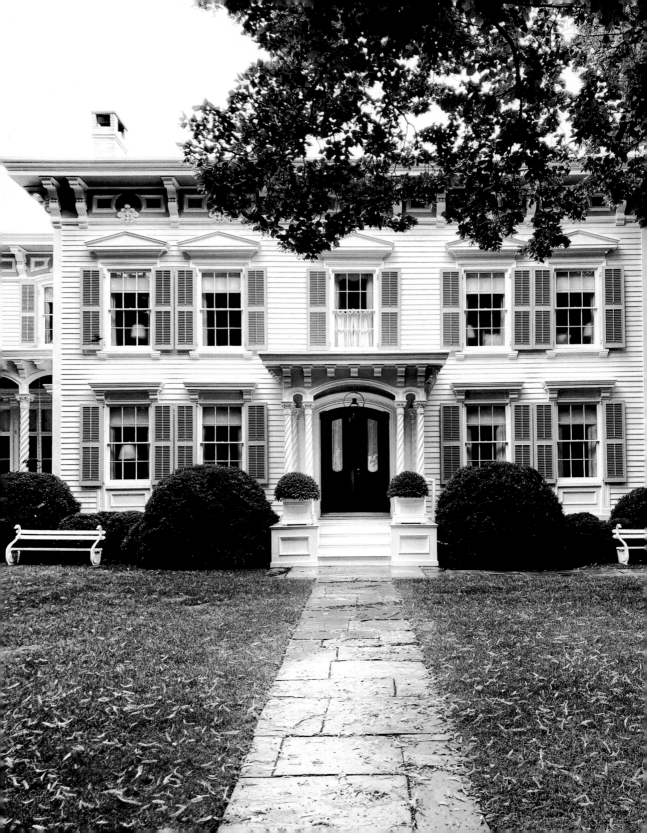

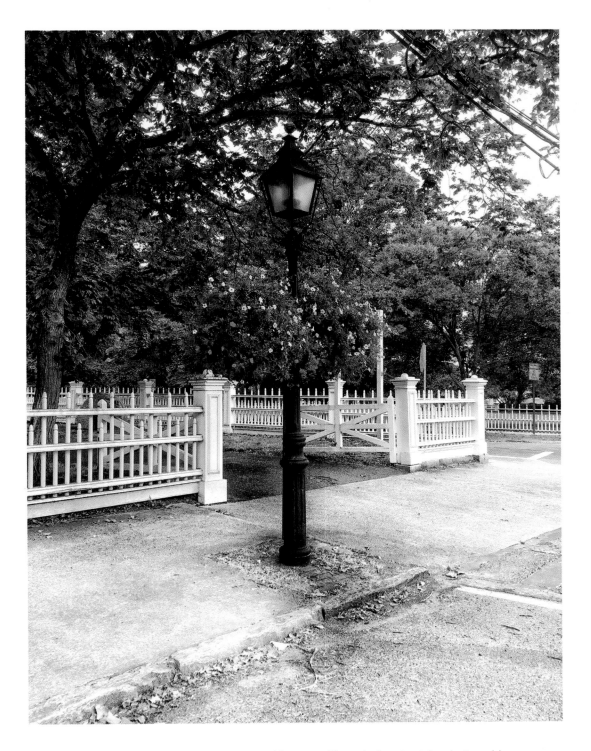

**OPPOSITE:** The "Hannibal French House" (ca. 1860) is a magnificent Italianate-style private residence on Main Street's "Captain's Row." **ABOVE:** Even the village's old-fashioned lampposts are beautifully decorated. The elaborate fence is part of the Whaling Museum on Main Street.

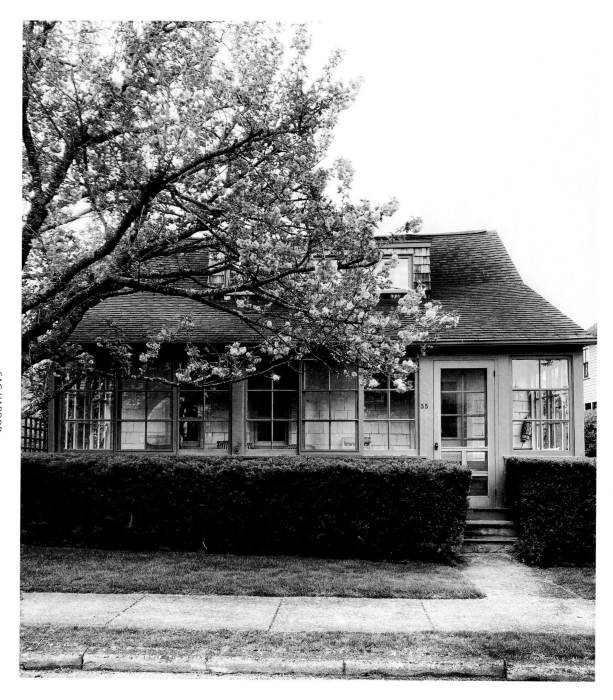

**ABOVE:** Cherry blossoms add even more pretty color to this lovely, blue-trimmed cottage on Garden Street. **OPPOSITE, CLOCKWISE FROM TOP LEFT:** A striking blue Greek Revival house on High Street; a sweet Victorian with a flower-filled garden on Jermain Avenue; a quaint blue cottage on Rector Street; an elegant early 1800s Georgian-style home on Suffolk Street

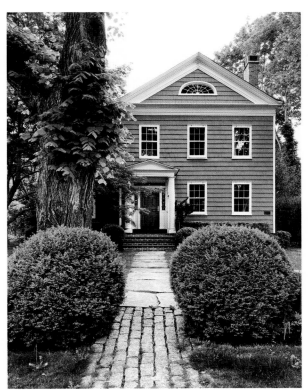
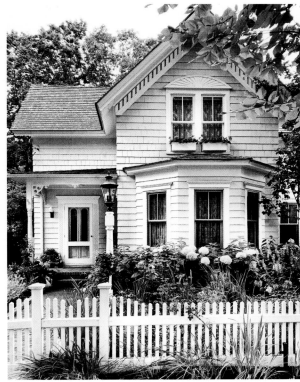
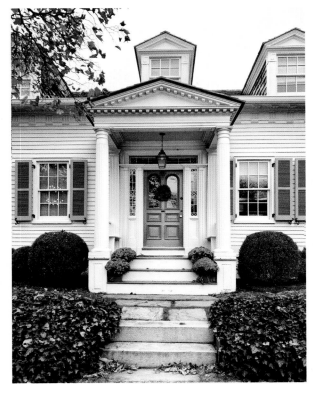
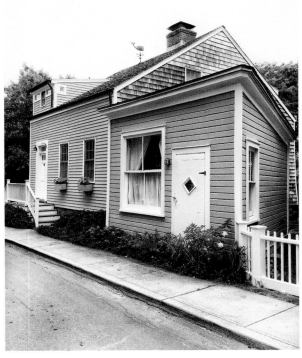

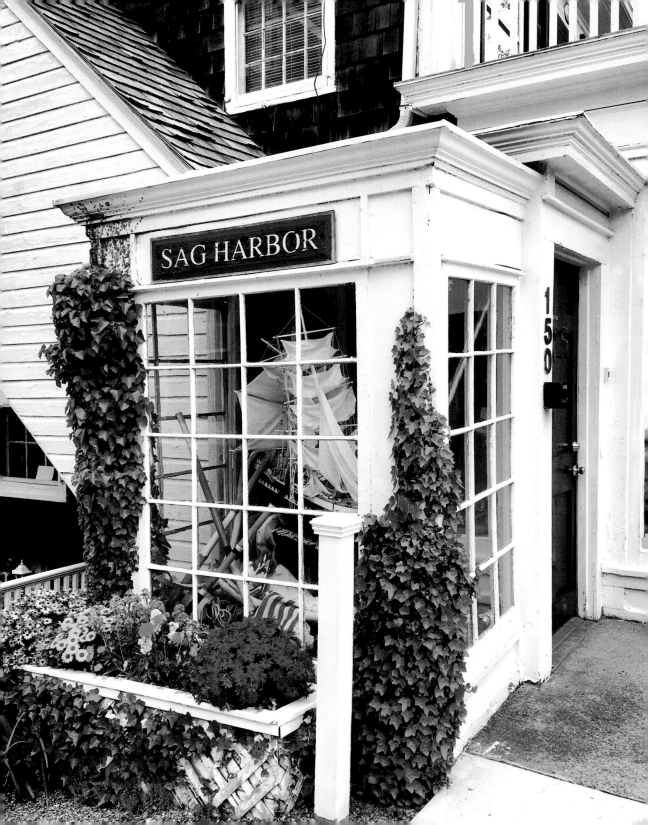

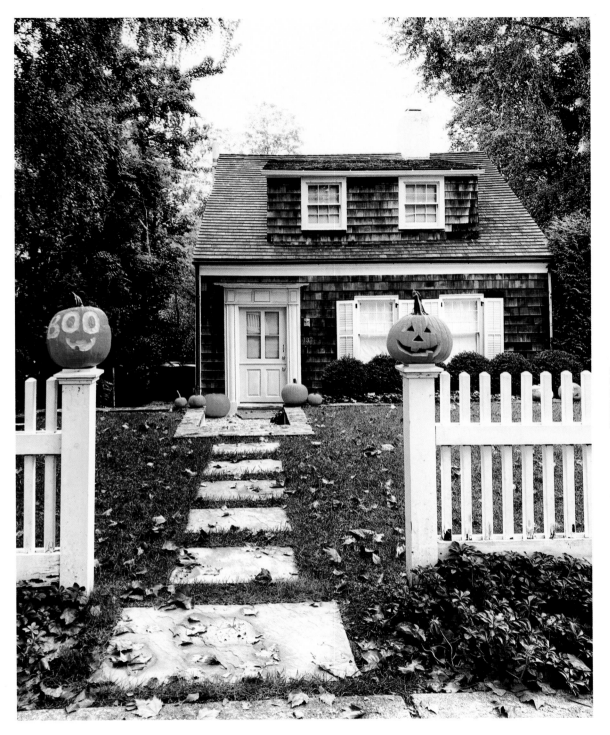

**OPPOSITE:** Antiques in the window of an antique building (ca. 1810) on Main Street
**ABOVE:** Carved Halloween pumpkins are more cute than scary at this charming, shingled
cottage (ca. 1790) on Madison Street.

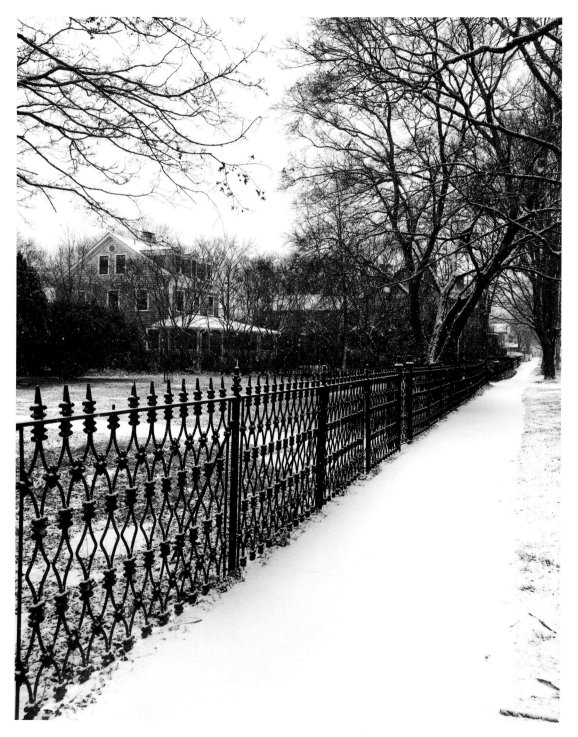

**ABOVE:** An intricately detailed iron fence stands out against a snow-covered Main Street sidewalk. **OPPOSITE:** Snow falling on this dramatic dark gray cottage creates a moody winter scene on Suffolk Street.

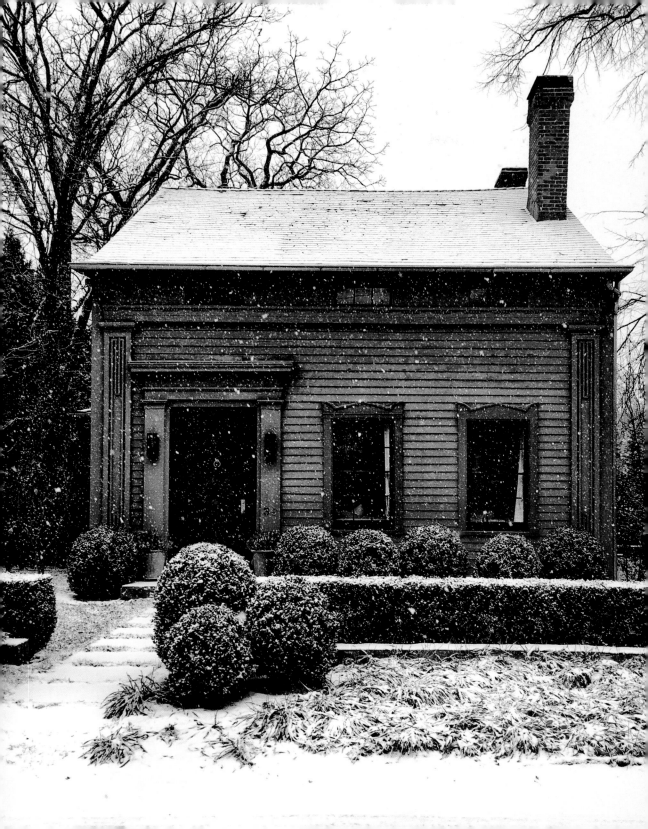

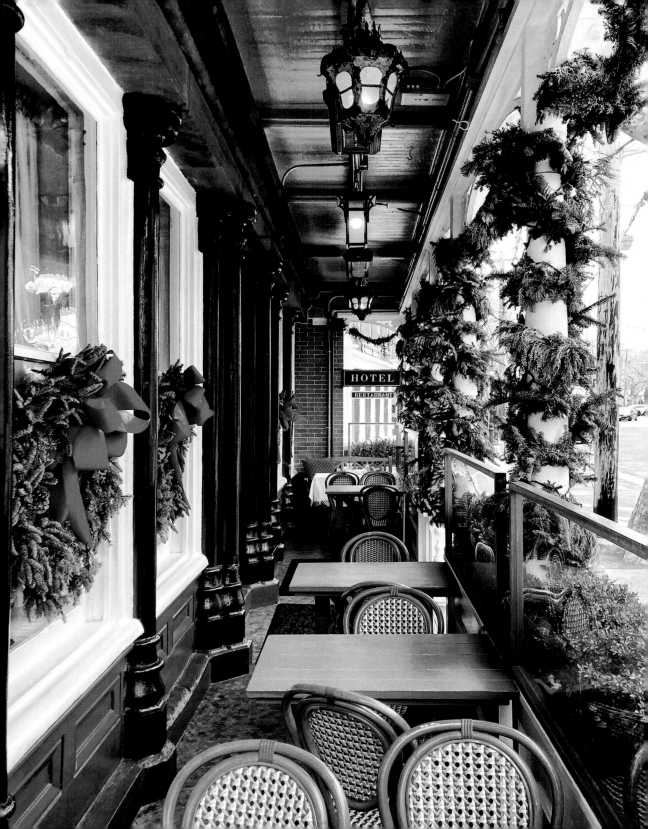

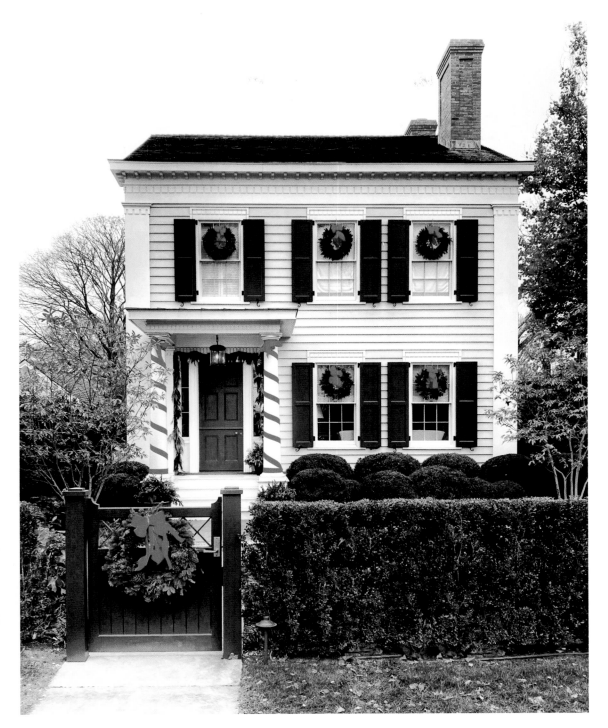

**OPPOSITE:** The porch of the iconic American Hotel (ca. 1845), a Main Street landmark, is beautifully decked out for the holidays. **ABOVE:** A perfectly restored Egyptian Revival–style house (ca. 1840), and the former home of Pulitzer Prize–winning playwright Lanford Wilson, is fun and festive on Suffolk Street.

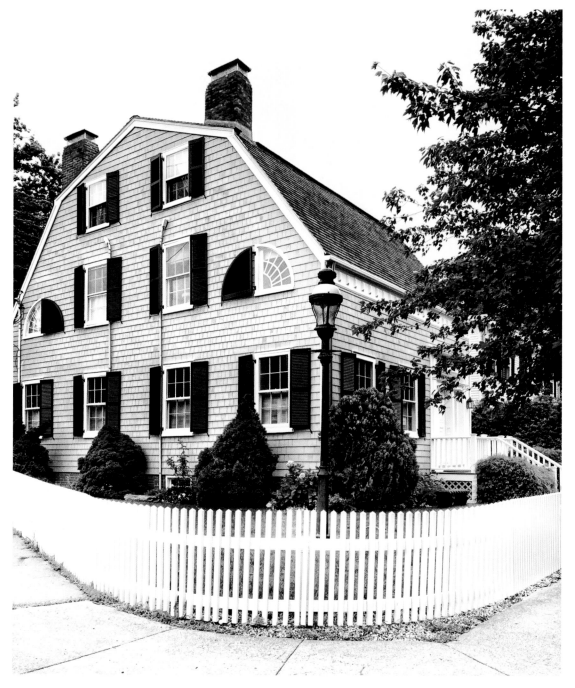

ABOVE: A handsome Federal-style house (ca. 1810) and classic white picket fence grace the corner of Jefferson and Main Streets. **OPPOSITE, CLOCKWISE FROM TOP LEFT:** An antique barn is the setting for Sage and Madison's gift shop on Sage Street; a fall wreath adorns the door of this 1797 landmarked house on Madison Street; festive garland at Sylvester & Co. general store's entrance on Main Street; black door and white pumpkins at 1818 Collective's shop on Madison Street

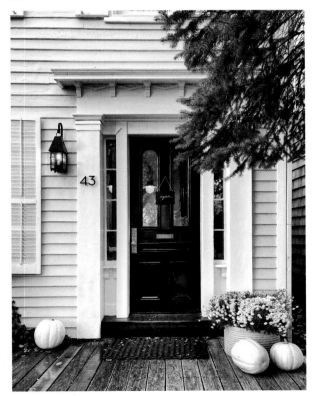
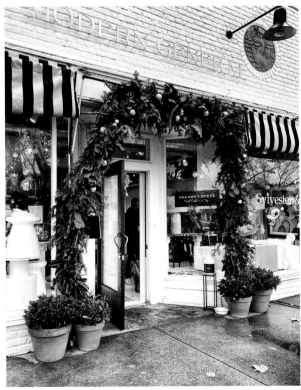

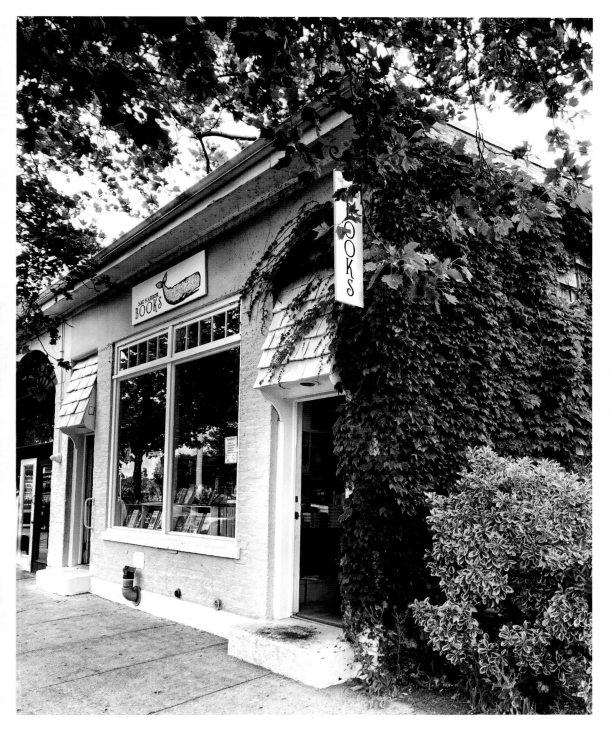

**OPPOSITE:** The striking Victorian "Hope House" (ca. 1860) is a standout on Main Street, and so is its whimsically sculpted privet. **ABOVE:** The ivy-covered Sag Harbor Books on Main Street is a booklover's dream shop.

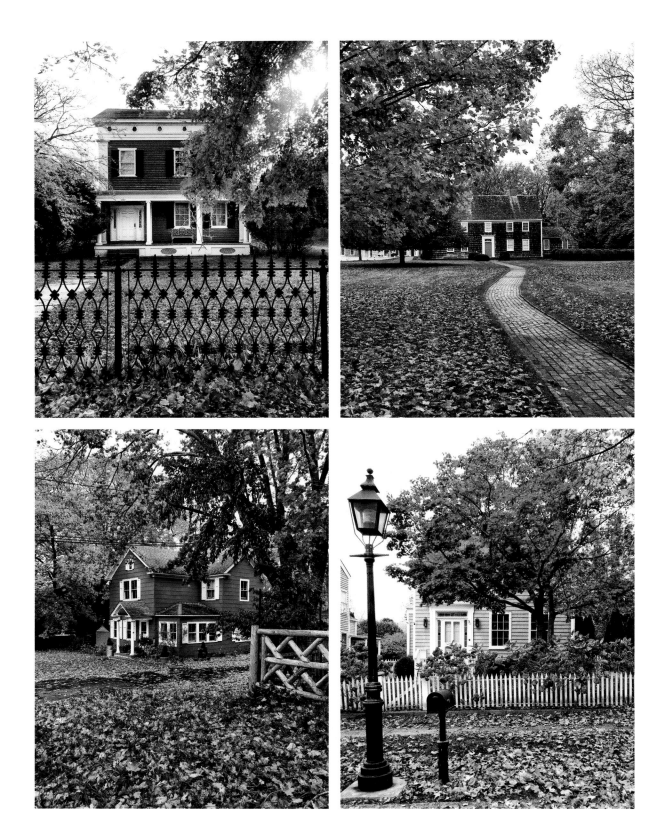

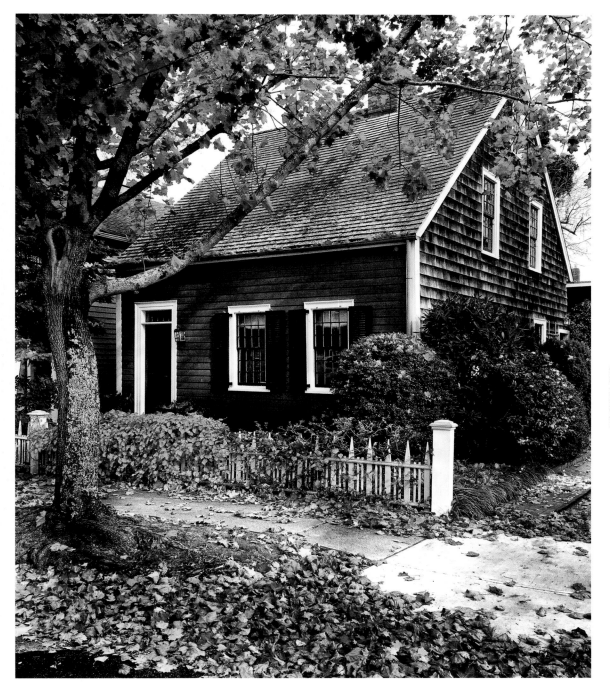

**OPPOSITE, CLOCKWISE FROM TOP LEFT:** A collection of colorful fall foliage: an elegant black-gray-and-white house on Main Street; the Custom House Museum (ca. 1790) on Main Street; gray house with vibrant red leaves on Hampton Street; rustic red farmhouse on Rysam Street **ABOVE:** A classic cottage (ca. 1791) on Madison Street looks perfectly cozy nestled in golden autumn leaves.

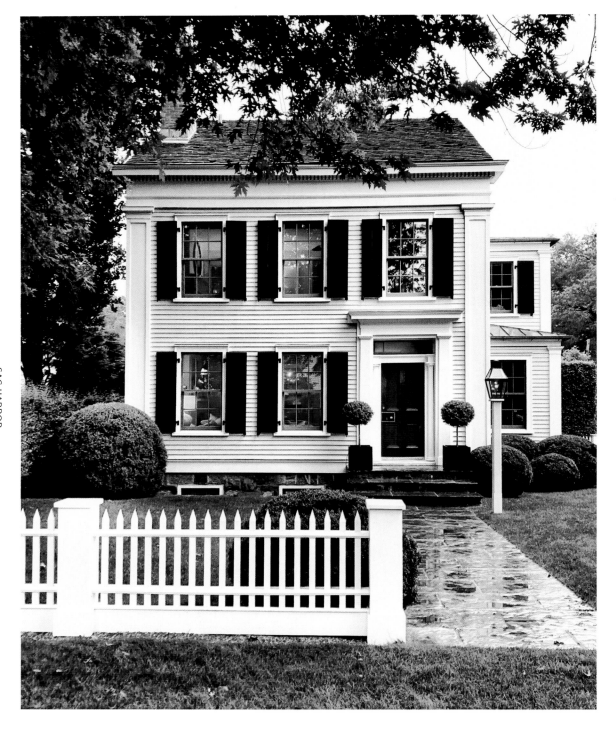

**ABOVE:** This beautifully restored sea captain's house (ca. 1854) on Suffolk Street gives off a warm and inviting glow on a rainy spring day. A teal-colored door adds a distinctive touch to this classic home.

# My Favorite Walks

SAG HARBOR

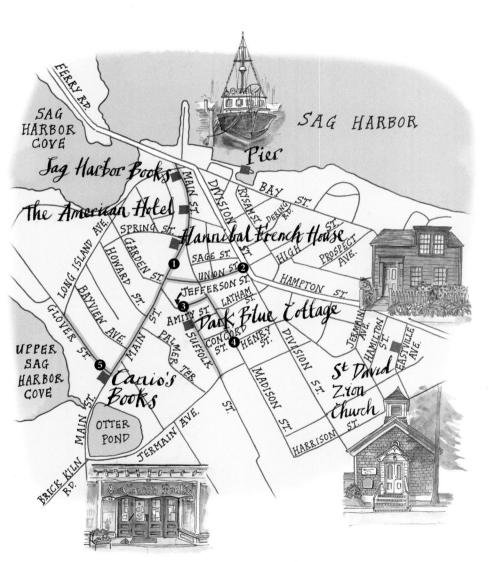

## WALKS:

**❶ Main Street**
The handsome "Captain's Row" of nineteenth-century houses line Main Street between Sage and Glover Streets.

**❷ Union Street**
From Division Street to Main Street, you pass the village's oldest cottage and the stunning Old Whalers' Church.

**❸ Suffolk Street**
Some of my all-time favorite cottages and captain's houses are between Jefferson Street and Jermain Avenue.

**❹ Madison Street**
An abundance of charming cottages can be found between Sage and Henry Streets.

**❺ Glover Street**
A fun mix of smaller cottages and beautifully restored sprawling homes

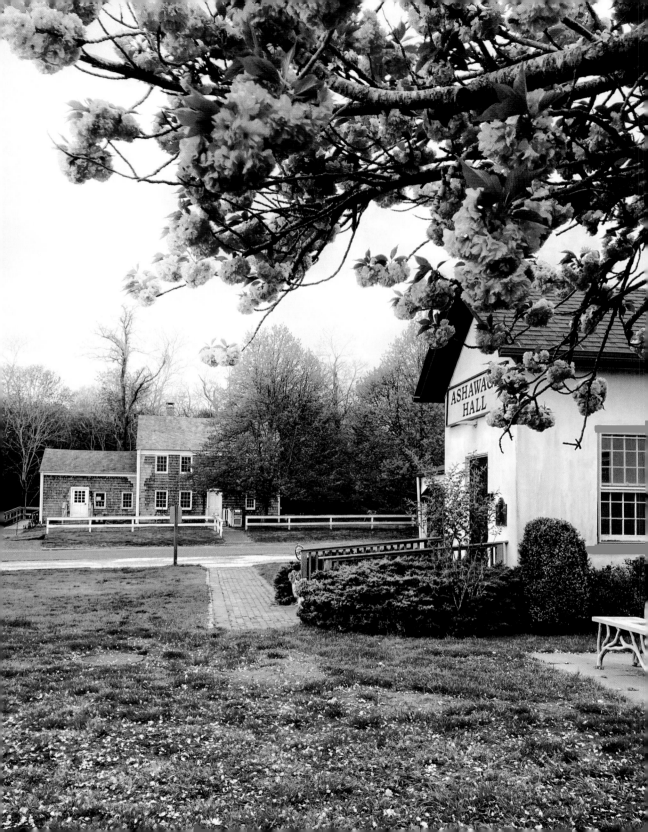

# SPRINGS

Long considered one of the Hamptons best-kept secrets, this working-class hamlet of proud "Bonackers" (named from the early settlers who fished the Accabonac Bay) is no longer such a secret. Originally a fishing and farming community, Springs, with its beautiful bay beaches and rural atmosphere, was until recently an affordable alternative to the more expensive and crowded Hamptons. But even with its newfound popularity (and rising home prices), the area has still managed to keep much of its low-key charm.

In many ways, the quiet neighborhood by the Accabonac Harbor (now designated a historic district) looks much the same as it did in 1945, when the painter Jackson Pollock and his wife, the artist Lee Krasner, bought their modest farmhouse here for $5,000. The 179-year-old Springs General Store, where Pollock once traded paintings for groceries, is still standing, though it has recently been sold. Ashawagh Hall, built as a schoolhouse in 1847, still sits on the triangular village green where the farmers market pops up every Saturday during the summer and art exhibits and community events are held throughout the year.

Springs is where I go when I want to take a break from the Hamptons' scene, especially during the summer months. It's only a short, traffic-free drive north on Old Stone Highway from Amagansett to my favorite bay beach, Louse Point. There, I can experience the natural beauty of the calm bay waters, watch paddleboarders, small sailboats, and kayakers go by, and soak up that special Hamptons light that painter (and Springs resident) Willem de Kooning once called a "miracle." And when I'm in the mood for a little culture, there's always the Pollock-Krasner House and Study Center on Springs Fireplace Road. Pollock's famed studio with its paint splattered floor and the house where he and Lee Krasner lived (and hosted so many other artists and writers) is the main draw, but I also relish the peaceful backyard view of the Accabonac Creek.

**OPPOSITE:** Ashawagh Hall on Old Stone Highway is framed by cherry blossoms, with the Springs Free Library in the background.

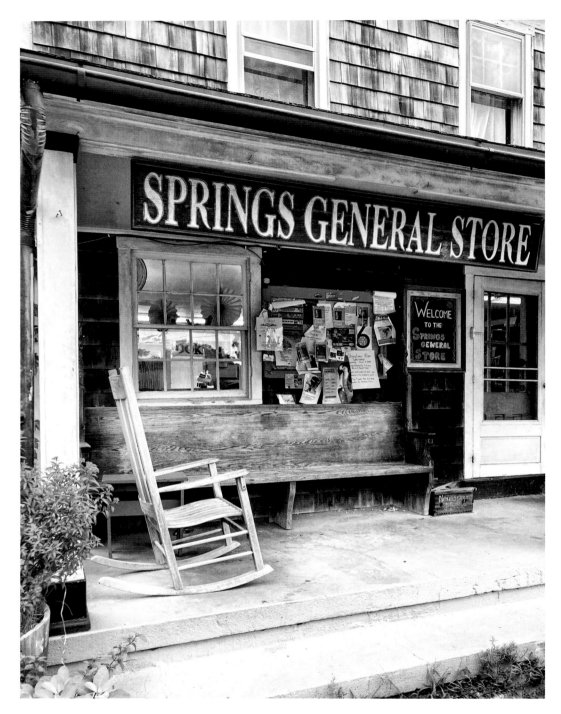

**ABOVE:** The iconic Springs General Store (ca. 1847) on Old Stone Highway was frequented by abstract expressionist painters Jackson Pollock and Willem de Kooning.
**OPPOSITE, CLOCKWISE FROM TOP LEFT:** A collection from the Springs General Store's property: retro gas pumps; a cute welcoming sign; blue Adirondack porch chairs; trumpet-vine-covered kayak and paddleboard rental shack

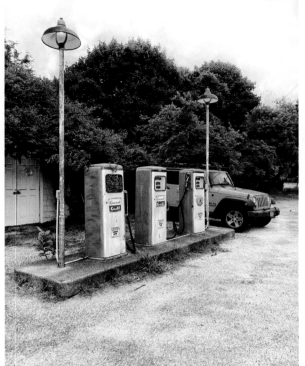

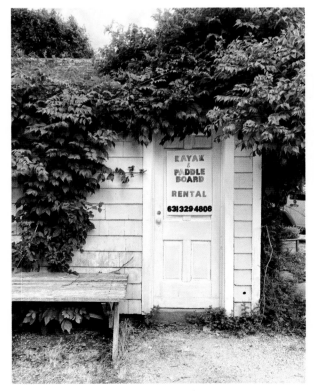

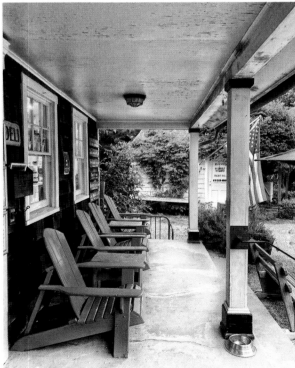

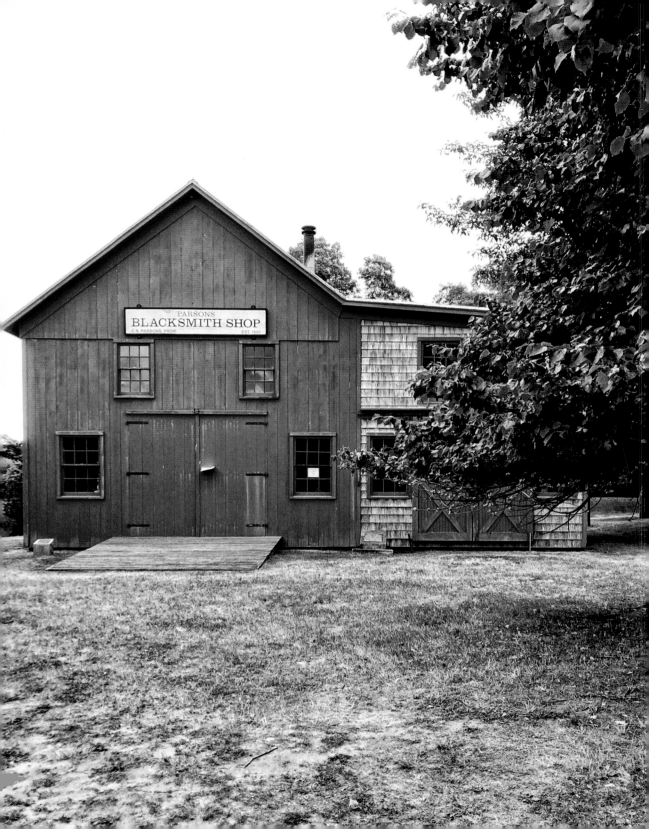

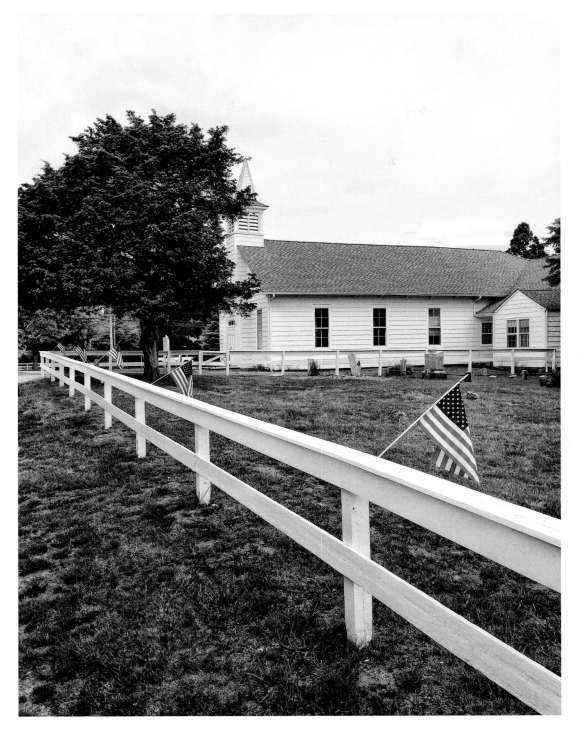

**OPPOSITE:** The Parsons Blacksmith Shop's red barn (ca. 1886), on Parsons Place in the Springs Historic District, still hosts traditional blacksmithing exhibitions. **ABOVE:** Memorial Day flags decorate the Presbyterian church's fence on Old Stone Highway.

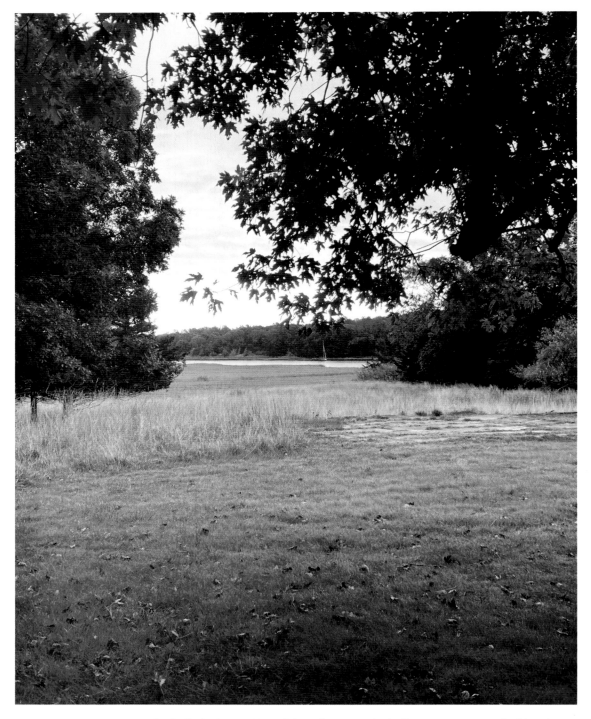

**ABOVE:** The Pollock-Krasner House's bucolic one-and-a-half-acre property overlooking the Accabonac Creek is now a designated nature preserve. **OPPOSITE:** Jackson Pollock's studio at the Pollock-Krasner House on Springs Fireplace Road was where Pollock created many of his famous poured canvases. It was declared a National Historic Landmark in 1994.

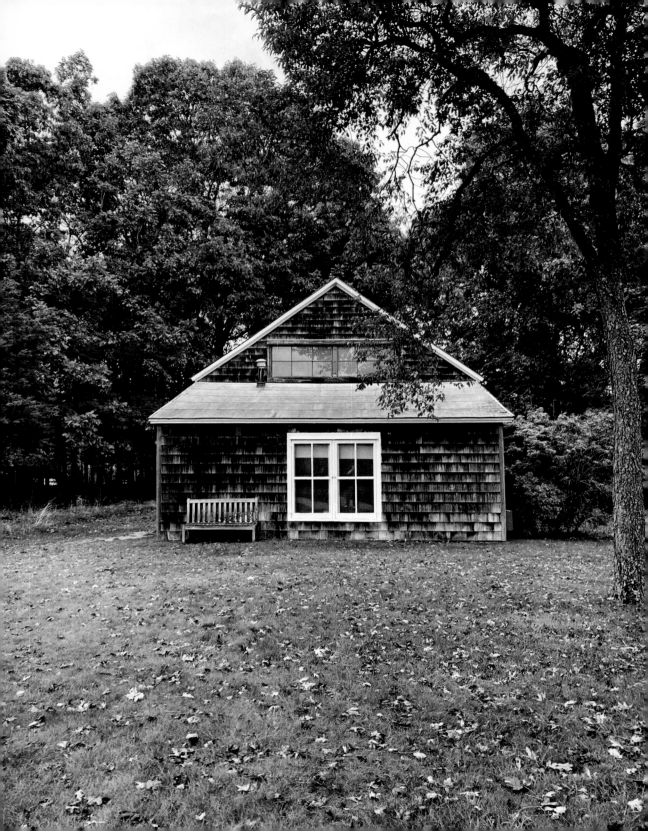

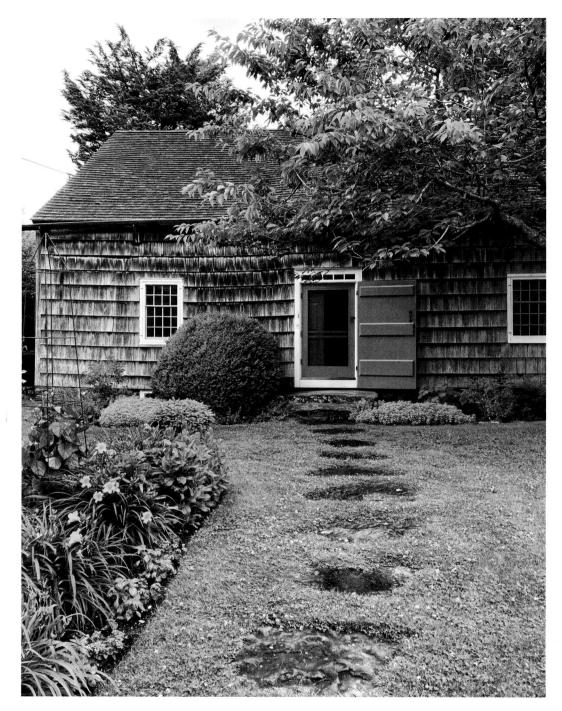

**ABOVE:** A charming eighteenth-century cottage (ca. 1750) with a sweet garden near Louse Point Beach **OPPOSITE, CLOCKWISE FROM TOP LEFT:** A black barn on Talmage Farm Lane; shingle house on Springs Fireplace Road; a private home with weathered gray shingles and a dusty-blue door; a simply chic dark blue farmhouse from the late 1700s on Springs Fireplace Road in the Historic District

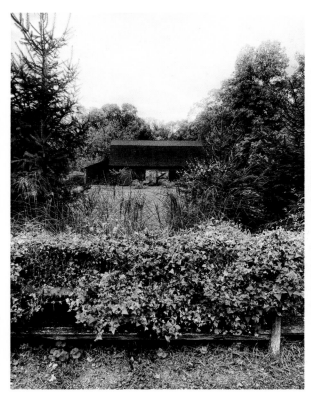

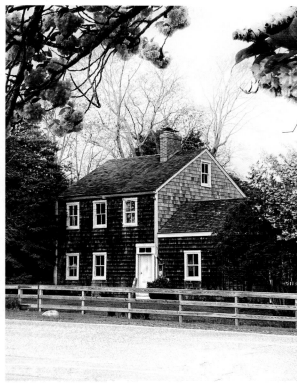

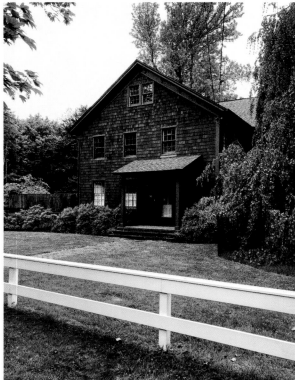

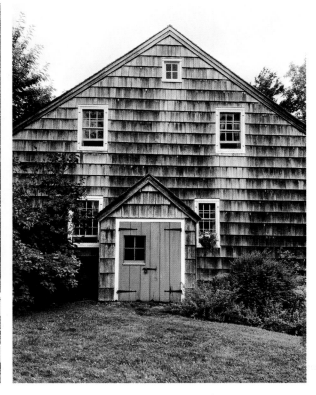

**ABOVE:** An old wooden bridge crossing Pussy's Pond in the Springs Historic District
**OPPOSITE:** A rustic sign on a country road points the way to Amagansett and Springs.

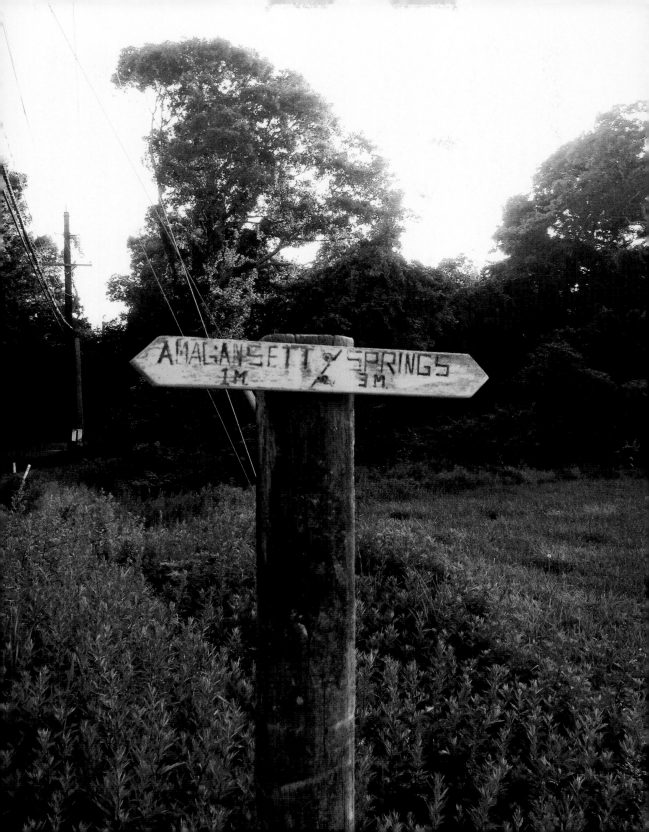

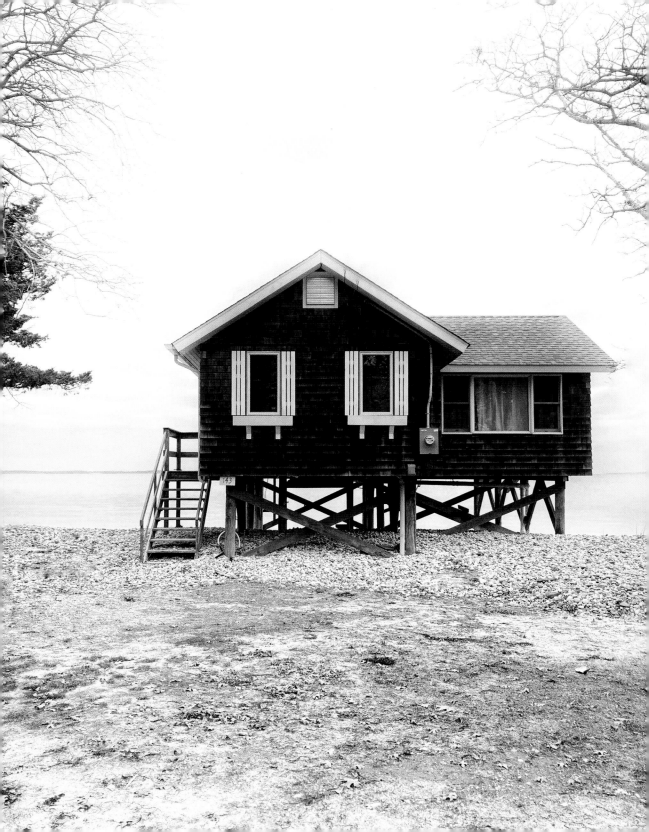

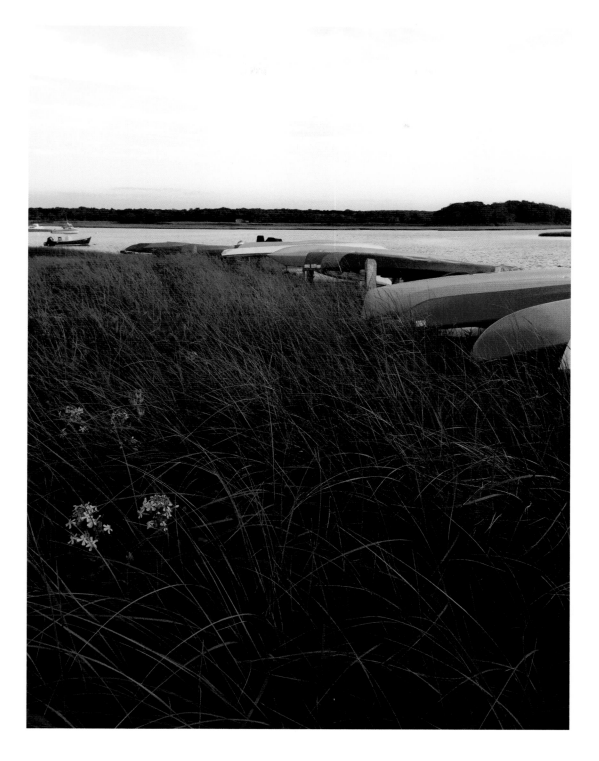

**OPPOSITE:** A modest beach house on Gerard Drive has a highly covetable view of the Napeague Bay. **ABOVE:** The serene beauty and magical light of Louse Point at dusk

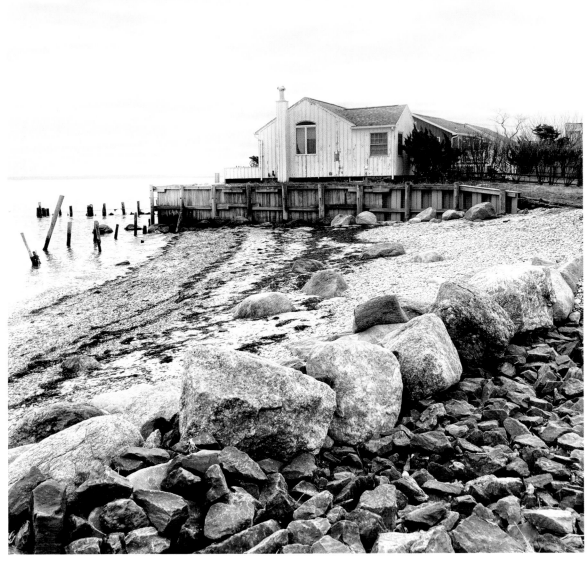

**ABOVE:** A small sandy beach, impressive boulders, and an unpretentious white house on scenic Gerard Drive

# My Favorite Walks and Drives

SPRINGS

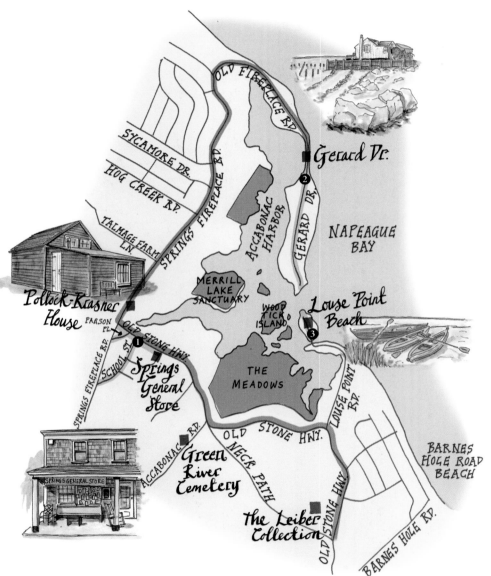

**WALKS:**

**❶ Old Stone Highway**
From School Street to Parsons Place, you'll pass Pussy's Pond, Springs General Store, and the historic Ashawagh Hall and blacksmith shop.

**❷ Gerard Drive**
A long walk with beautiful views of the Accabonac Harbor and laid-back beach houses

**❸ Louse Point Beach**
A favorite for sunset strolls along the quiet bay beach

**DRIVES:**

**≡ Old Stone Highway**
A lovely winding road through dense trees, with quaint cottages along the way

**≡ Springs Fireplace Road**
From the Pollock-Krasner House you'll experience the rural atmosphere, old farmhouses, and bay views.

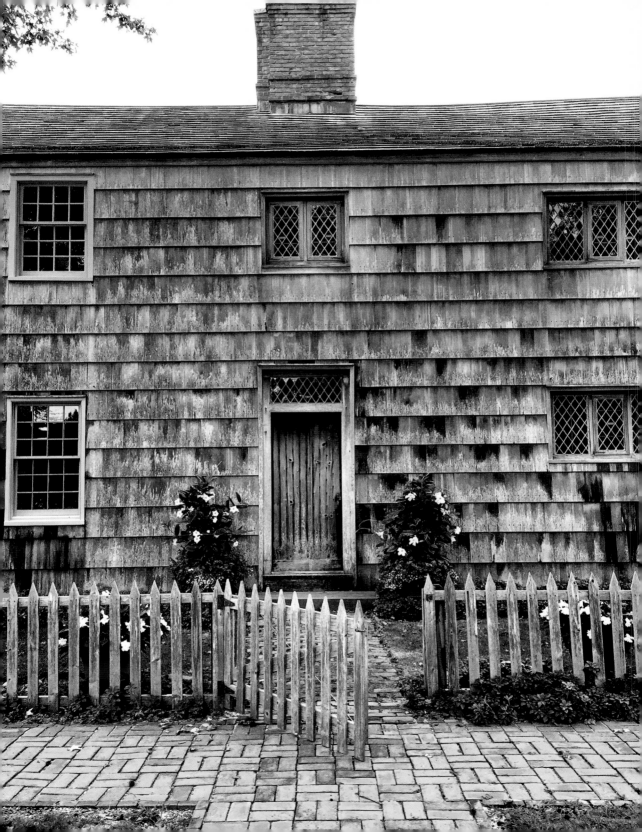

# SOUTHAMPTON

Southampton Village (named after the British Earl of Southampton) is the oldest and largest of all the Hamptons. This first permanent English settlement in New York State was founded in 1640 by a small group of Puritans from Lynn, Massachusetts, who were welcomed by the Shinnecock Indians on what is now known as Conscience Point. (The Shinnecock Indian Nation now retains a reservation on the east side of the Shinnecock Bay in Southampton.)

I discovered Southampton back in the late 1970s. It was the sophisticated Hampton where my girlfriends and I would shop at trendy boutiques on Jobs Lane and dance at the hot discos (whose names I've long forgotten) on Route 27. The village's picturesque homes and landmarks weren't exactly top of mind for me back then. Now, there's nothing I like more than strolling down South Main Street and admiring classic saltboxes like the Thomas Halsey House (ca. 1683) or driving along Gin and Meadow Lanes (the heart of the original summer colony) and gawking at the majestic oceanfront mansions—although many are hidden behind sky-high hedges.

These stunning estates didn't start appearing until the Long Island Rail Road reached Southampton in 1872, making the area easily accessible to Manhattanites. By the end of the nineteenth century, many wealthy New York society families, including the Rockefellers and Vanderbilts, had arrived, and a fashionable new summer resort was born.

Today, even with the arrival of reality stars and new money, the Old Guard continues to dominate the social scene, making Southampton the most exclusive and staid of all the Hamptons. (I think of it as the "Upper East Side by the sea.")

But shopping the stylish boutiques on Jobs Lane, grabbing a bite at a sidewalk café on Main Street, visiting the Southampton Arts Center, or just taking a walk on stunning Coopers Beach is a pleasure that anyone can enjoy.

**OPPOSITE:** The historic Thomas Halsey House, one of Southampton's oldest houses (ca. 1680), is now a museum on South Main Street.

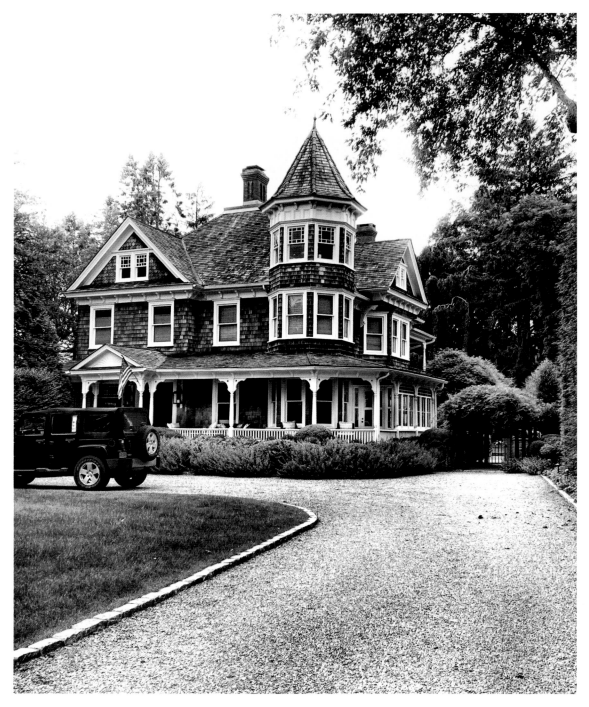

**ABOVE:** An outstanding Queen Anne–style house with a lovely veranda and pretty catnip plantings on North Main Street **OPPOSITE, CLOCKWISE FROM TOP LEFT:** A bold green door adds a pop of color to a classic white house on Toylsome Lane; a grand ivy-covered brick mansion from 1913 on South Main Street; a classic white house with perfectly placed boxwoods on Post Crossing; a storybook cottage on Lewis Street

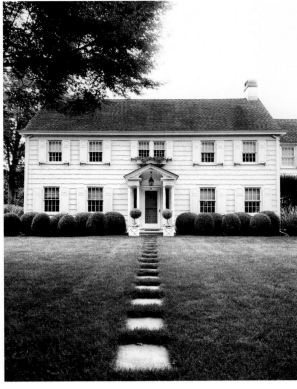

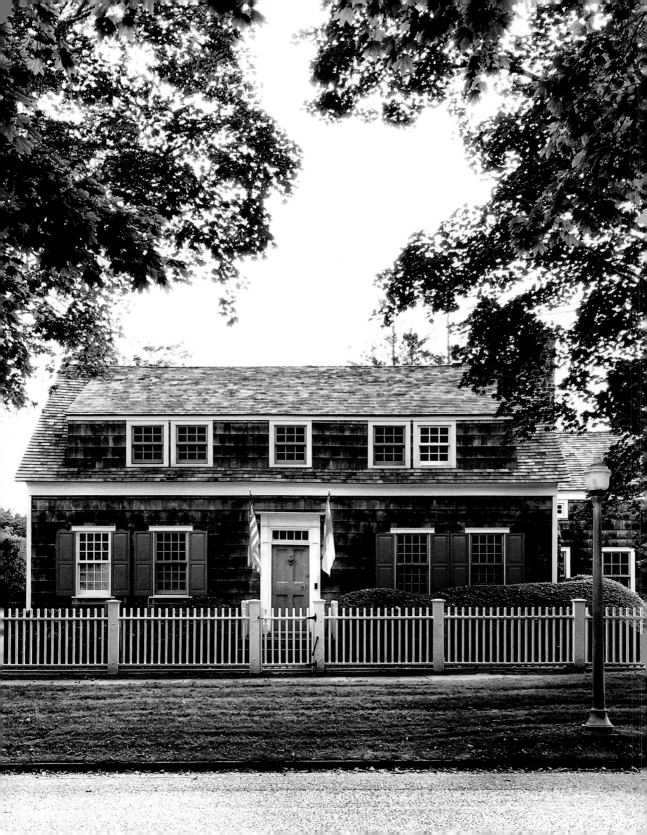

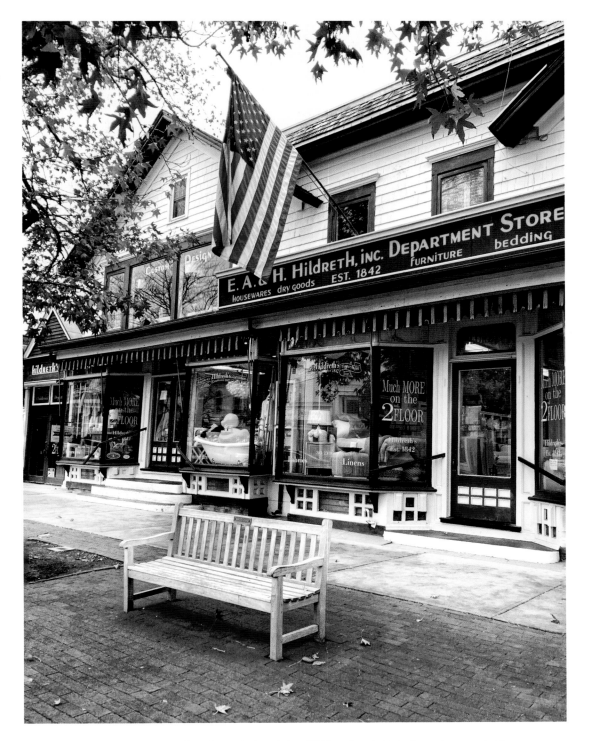

**OPPOSITE:** The rectory of St. John's Episcopal Church (ca. 1730) on South Main Street is eye-catching with its bold red shutters and door. **ABOVE:** A flag is flying on Main Street's Hildreth's Department Store, one of the country's oldest department stores, established in 1842, and still going strong.

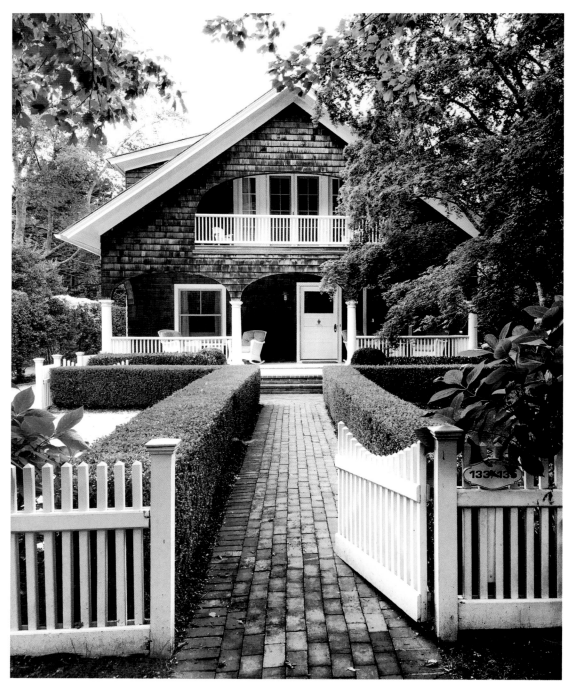

**ABOVE:** Perfectly manicured hedges create a pathway to this distinctive shingled house on Toylsome Lane. **OPPOSITE, CLOCKWISE FROM TOP LEFT:** Lush ferns adorn the porch of this South Main Street house (ca. 1789); a late nineteenth-century classic shingle on Post Crossing; the Dr. Hallock House (ca. 1866), another South Main Street landmark; dating from ca. 1695, this South Main Street shingle stayed in the original family for eight generations

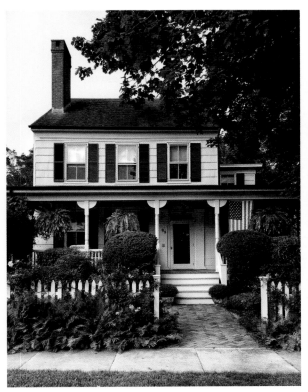
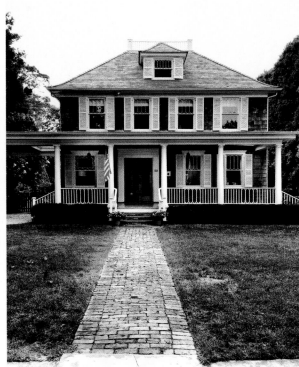
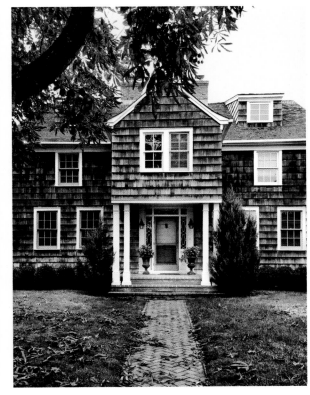
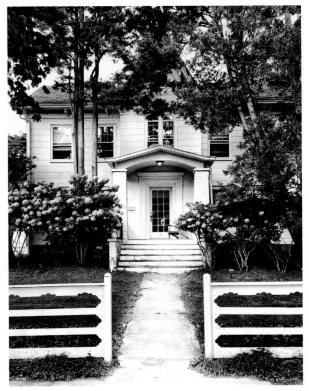

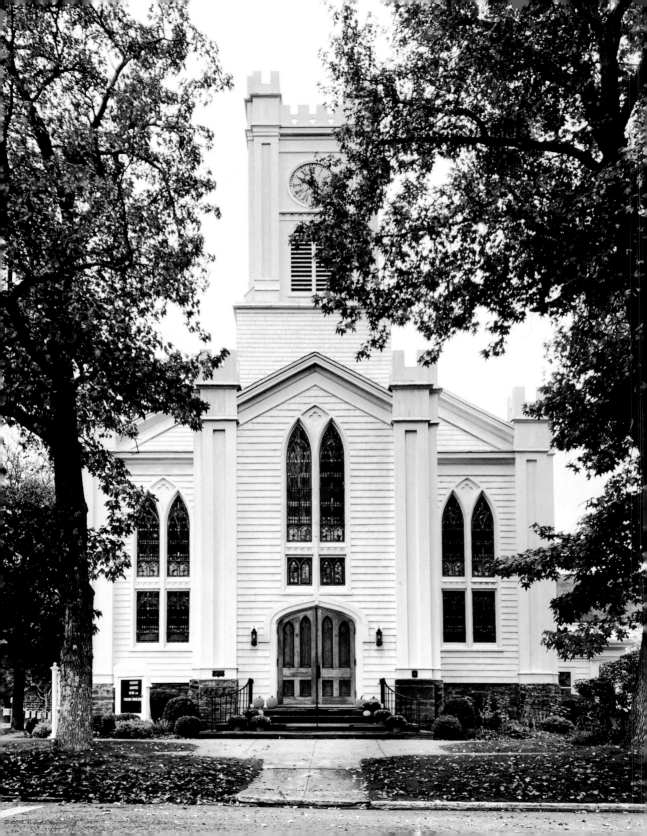

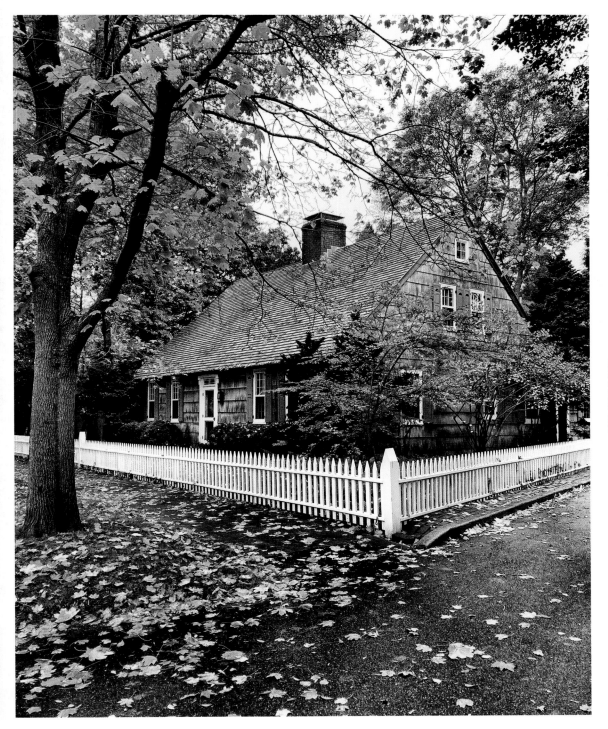

**OPPOSITE:** Pumpkins and mums decorate the entrance to the First Presbyterian Church (ca. 1843), a classic Carpenter Gothic style on Main Street. **ABOVE:** A picturesque antique cottage (ca. 1742) is surrounded by brilliant fall foliage on the corner of South Main Street and Linden Lane.

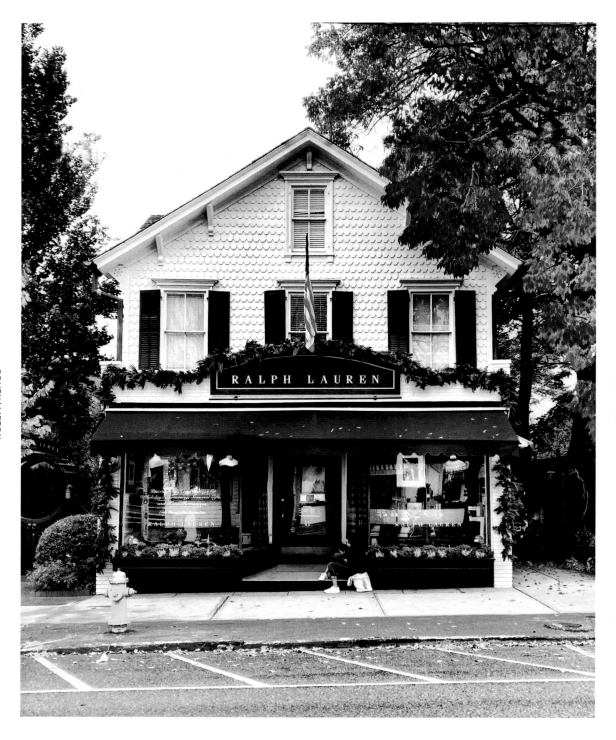

**ABOVE:** Ralph Lauren's charming shop on Jobs Lane is already decorated for the holidays on a late fall day.  **OPPOSITE:** Topiaire Flower Shop is in the fall and Halloween spirit with its spooky sidewalk display on Jobs Lane.

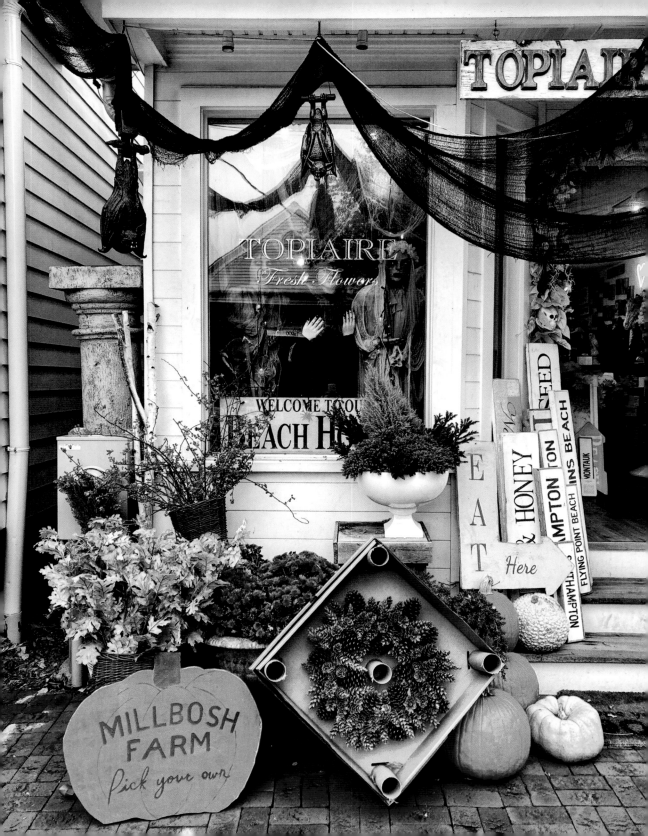

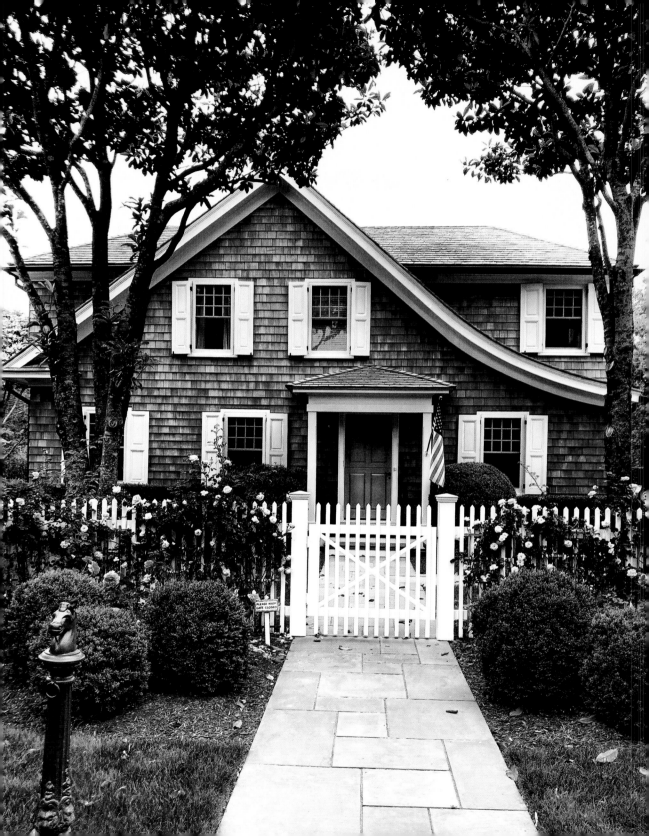

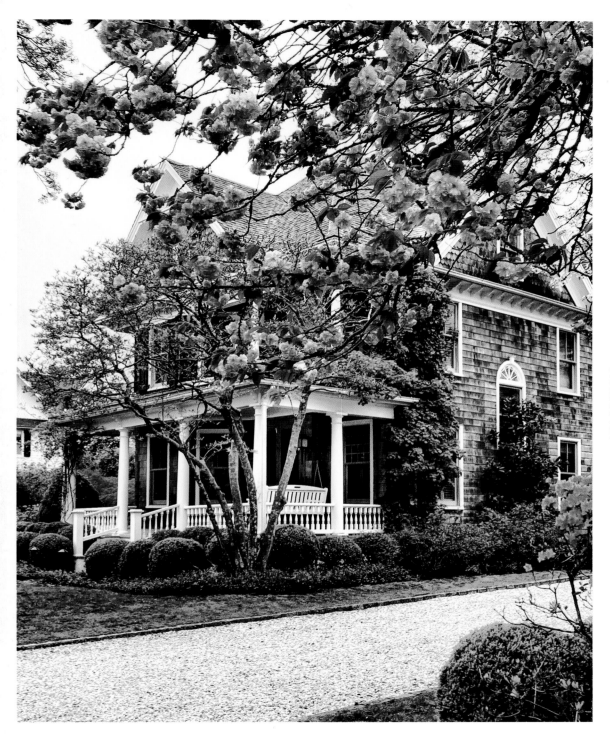

**OPPOSITE:** A sweet, shingled cottage with white shutters and a rose-covered white picket fence on Little Plains Road is the very definition of charming. **ABOVE:** Pretty cherry blossoms on Post Crossing partially hide this lovely Queen Anne–style home.

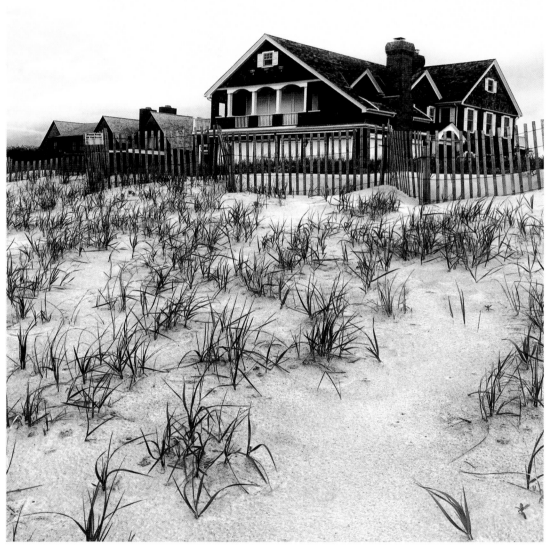

**ABOVE:** A grand beachfront house on Gin Lane can be seen from Old Town Beach.
**OPPOSITE, CLOCKWISE FROM TOP LEFT:** A Meadow Lane mansion on Shinnecock Bay; beach fencing on Old Town Beach; a weathered wooden dock off Meadow Lane leads to Heady Creek; the charming concession stand at Coopers Beach on Meadow Lane

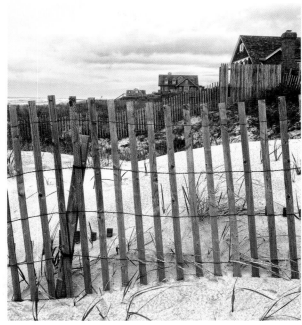

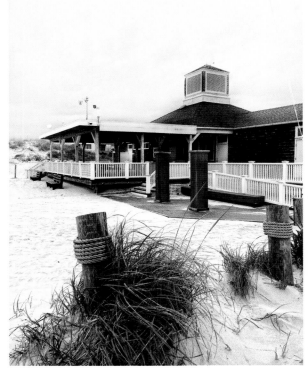

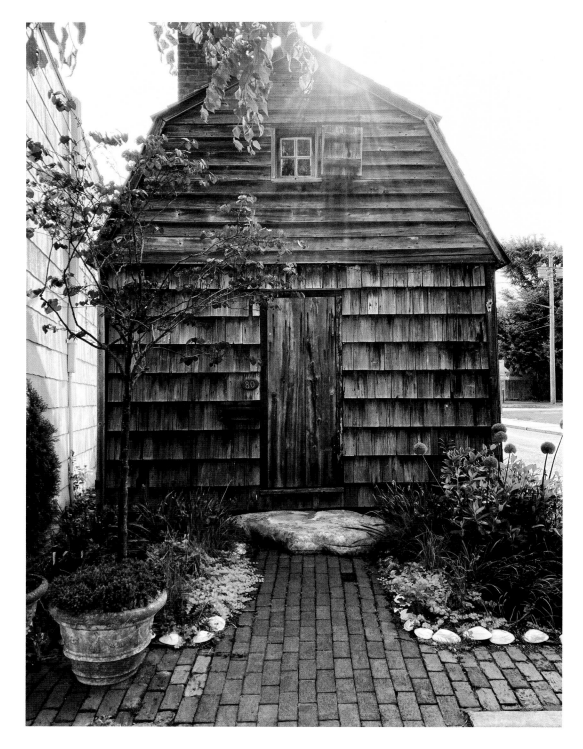

**ABOVE:** The tiny but historically significant Pelletreau Silver Shop on Main Street (built in 1686) is the oldest continuously opened shop in the Americas.

# My Favorite Walks and Drives

SOUTHAMPTON

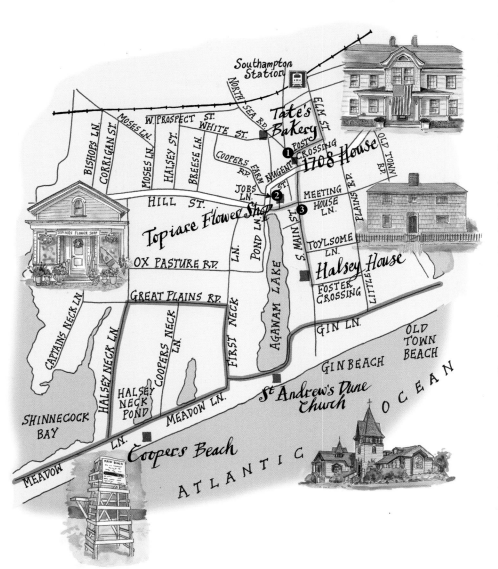

**WALKS:**

**❶ Post Crossing and Elm Street**
Two of the best streets for architectural gems including Queen Anne and shingle styles

**❷ Jobs Lane**
A charming block filled with a variety of shops and the Southampton Arts Center

**❸ South Main Street**
Historic homes and grand old estates are found between Jobs Lane and Foster Crossing.

**DRIVE:**

**≡ Gin Lane to Meadow Lane**
Mostly manicured hedges and eye-catching gates, but also glimpses of the original "summer colony" mansions and lovely views of Agawam Lake and the Shinnecock Bay

# AMAGANSETT

When my husband and I bought our quaint cottage in Amagansett we didn't know much about this 6.6-square-mile hamlet with its pristine ocean beaches, charming village square brimming with shops, leafy tree-lined lanes, and classic summer "cottages" along Bluff Road. How could I have spent so many summers in neighboring East Hampton but never have visited this lovely village just a mere two miles down the road? Twenty-seven years later, I feel like I know every square inch of this little town I call home.

Amagansett, "place of good water," was named by the Montaukett Indian tribe after discovering a freshwater source near Indian Wells Beach. I've strolled the short Main Street (originally laid out by English and Dutch settlers in 1672) and admired Miss Amelia's Cottage Museum (ca. 1750) and the Phebe Cottage (ca. 1805). I've checked out what bands are playing at the legendary local bar and music venue Stephen Talkhouse, shopped at indie boutiques in Amagansett Square, bought fresh local corn at Balsam Farm, and spent countless hours at Amber Waves Farm's market and café, sipping coffee, catching up with friends, and snapping photos of their pretty flower fields.

For me, each season in Amagansett holds spellbinding natural beauty: horse chestnut and cherry trees bloom in spring along Main Street; the magnificent hydrangeas, roses, and sunflowers bloom all summer; the leaves on Windmill Lane turn the most vibrant colors in fall; and sparkling snow dusts the cottages and fields in winter.

Legend has it that Marilyn Monroe also fell under the spell of Amagansett when, in 1957, she and her husband, playwright Arthur Miller, spent the summer in a converted windmill on Deep Lane. And while much has changed since her summer idyll—a residential building boom took place in the 1970s and '80s and trendy shops and restaurants now line Main Street—the small-town vibe remains a draw for celebrities like Paul McCartney, Gwyneth Paltrow, Sarah Jessica Parker, and Matthew Broderick.

**OPPOSITE:** The "Conklin House," a delightful Victorian house (ca. 1898) on Main Street, features an etched "C" on the diamond-shaped third-floor window.

**ABOVE:** My classic Linus bike is parked at the entrance to Amagansett Square on Main Street.
**OPPOSITE:** Beautiful blue and lavender hydrangeas in full bloom in Amagansett Square

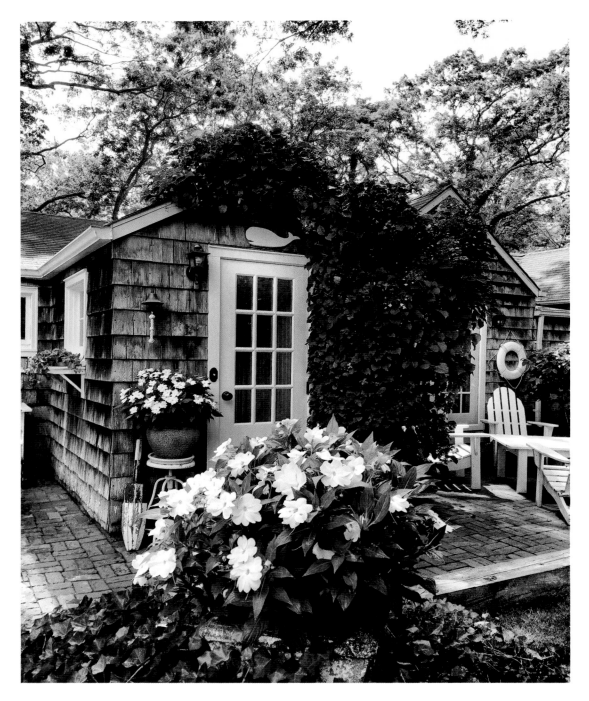

**ABOVE:** The brick patio and back door of my quaint 1890s cottage is accessorized with white impatiens, a climbing hydrangea, and fun nautical details. **OPPOSITE, CLOCKWISE FROM TOP LEFT:** Miss Amelia's Cottage Museum (ca. 1725), on Main Street; a view of my trumpet vine–covered garage, black Lab, Lucky, and blooming summer hydrangeas; a classic white farmhouse (ca. 1890) on Main Street; June roses and a weathered split rail fence off Main Street

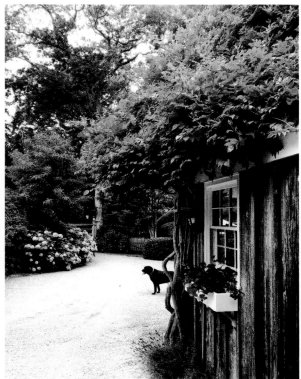
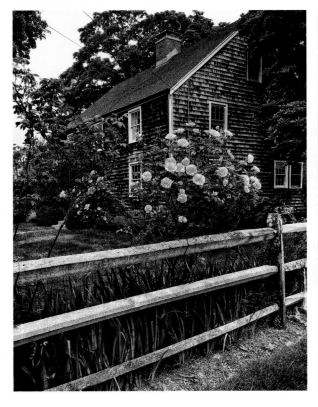
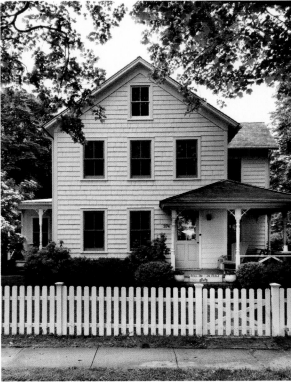

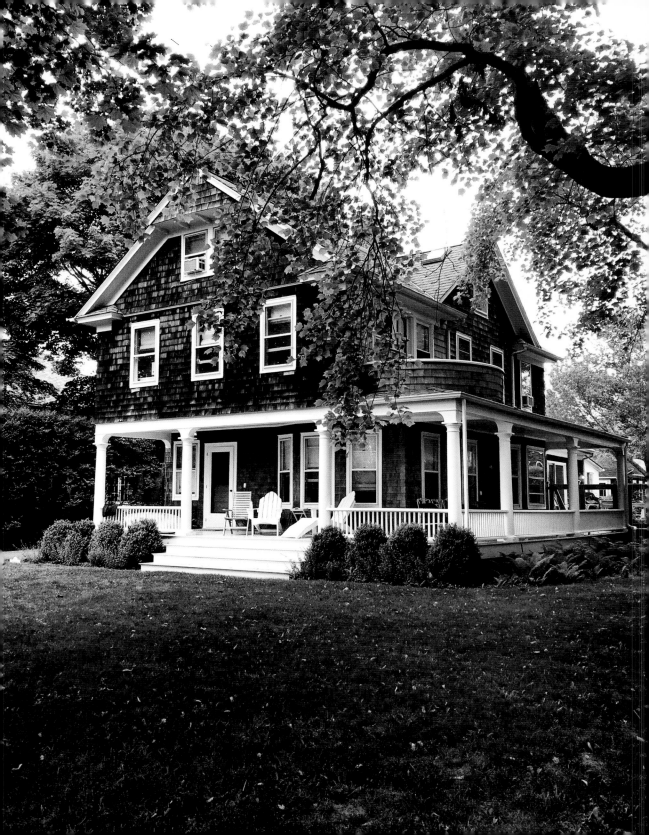

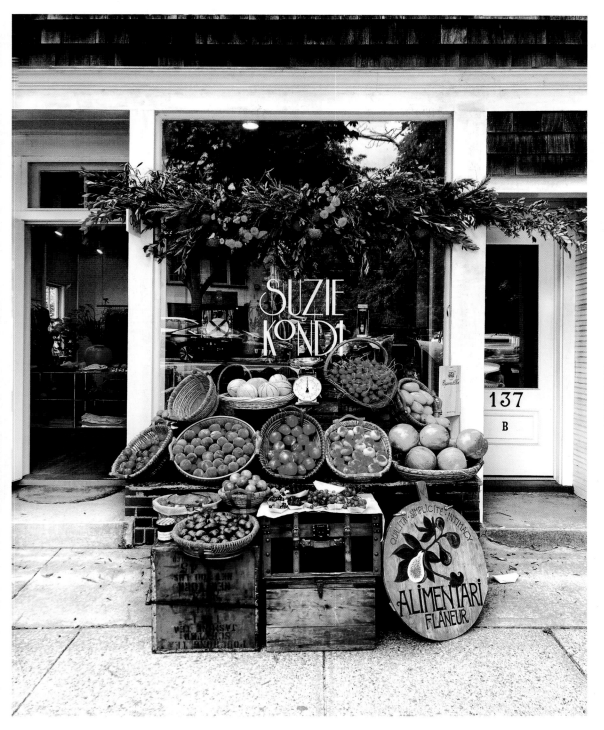

**OPPOSITE:** A quintessential Hamptons shingle-style cottage (ca. 1914) with an inviting wraparound porch on Meeting House Lane **ABOVE:** Alimentari Flaneur's summer pop-up fruit stand livens up the sidewalk in front of Suzie Kondi's clothing shop on Main Street.

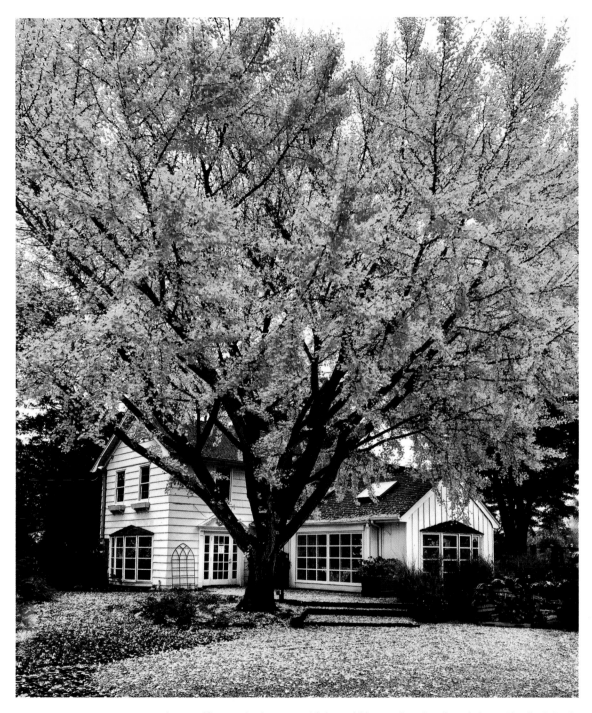

**ABOVE:** A magnificent gingko tree, with its gold leaves, is a dazzling sight at Charlie & Son's garden shop on Montauk Highway. **OPPOSITE, CLOCKWISE FROM TOP LEFT:** Fall mums at Amber Waves Farm; a golden-leaf-covered front yard on Main Street; the Reform Club's windmill framed by fall leaves on Windmill Lane; the Old Amagansett Schoolhouse on Main Street is the village's original one-room schoolhouse built in 1802

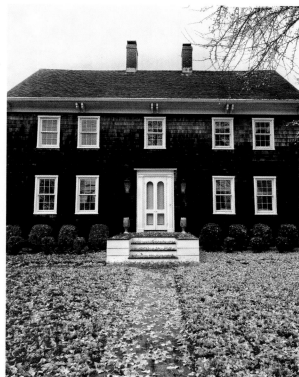
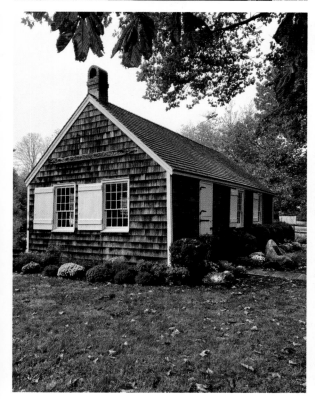
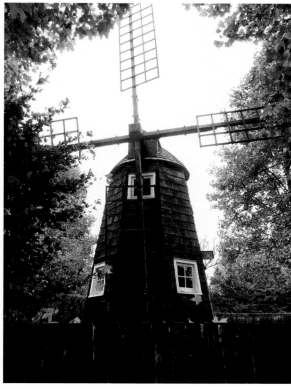

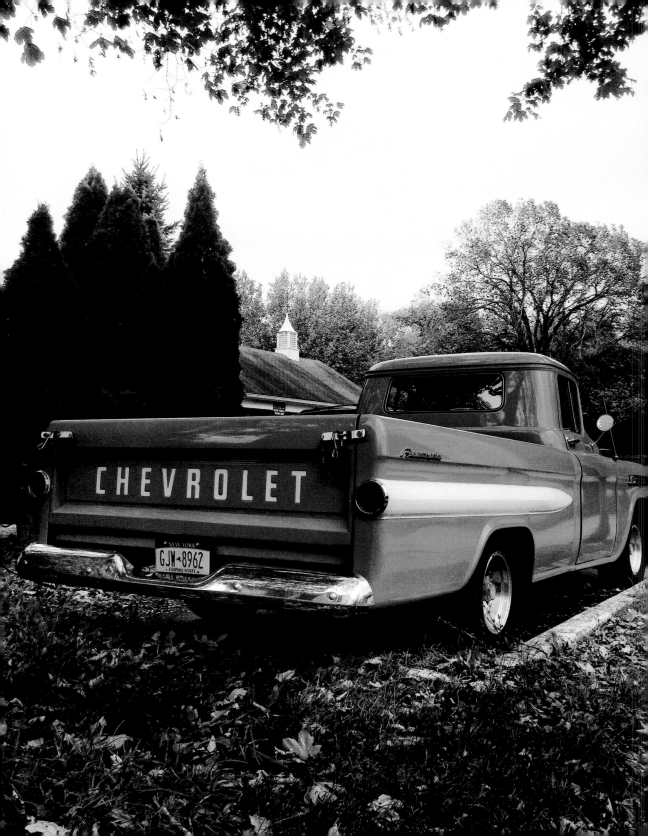

**OPPOSITE:** A mint-green vintage '59 Chevy Apache pickup truck adds a touch of nostalgia to Main Street. **ABOVE:** A charming old farmhouse with green trim and tall grass on Windmill Lane has a romantic rural feeling.

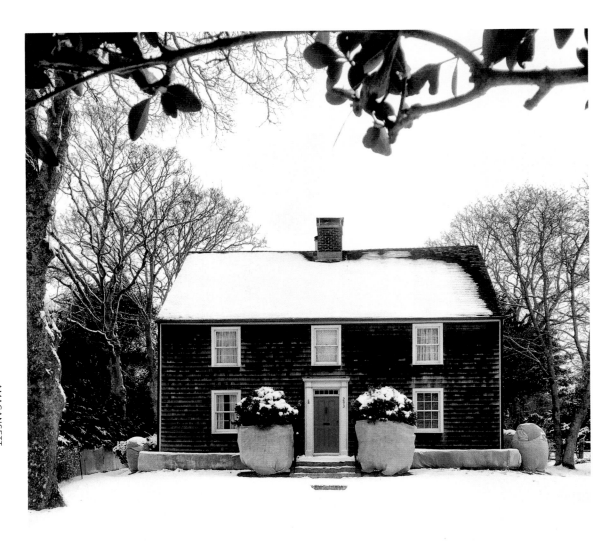

**ABOVE:** Burlap-covered shrubs and a bright red door make quite a statement at this traditional center-hall house on Main Street. **OPPOSITE, CLOCKWISE FROM TOP LEFT:** A sign for Stuart's Seafood points the way to their Oak Lane shop; a former livery stable on Indian Wells Highway; the red Lester Barn (ca. 1850) pops against a snow-covered field on Main Street; Jack's Stir Brew coffee shop on Main Street

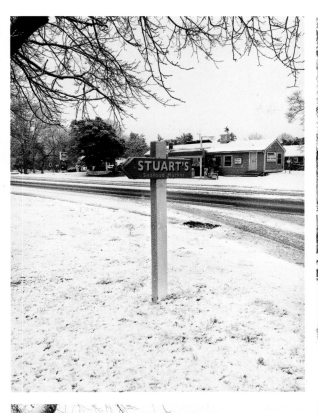
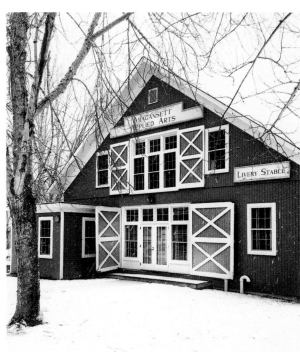

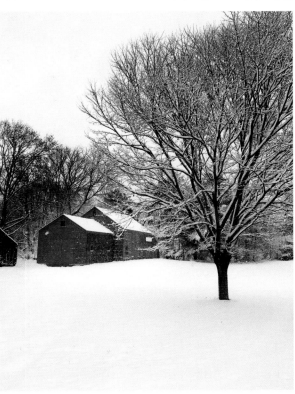

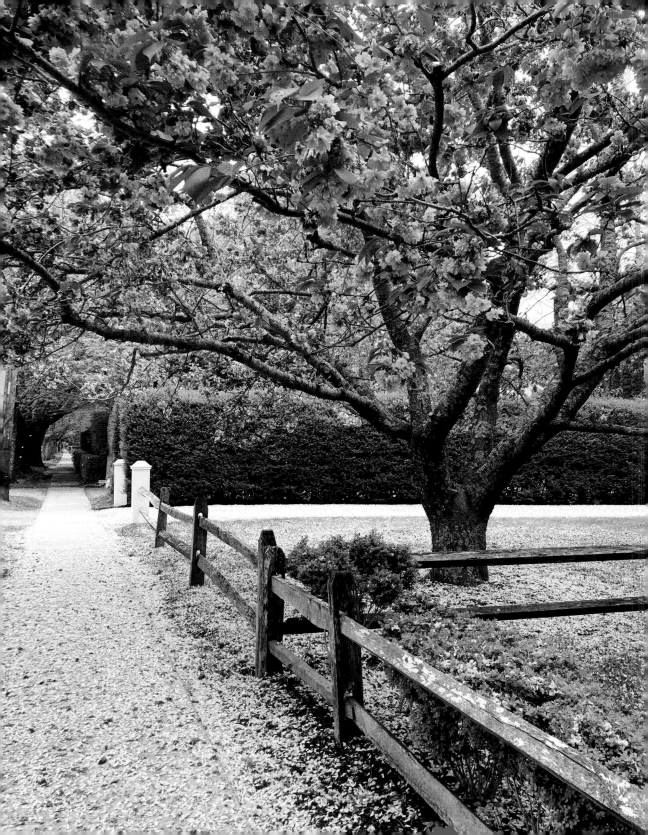

AMAGANSETT

**OPPOSITE:** A magical carpet of cherry blossoms on Main Street near Meeting House Lane
**ABOVE:** Vibrant purple catnip lines the walkway leading to Scoville Hall, a community center on Meeting House Lane.

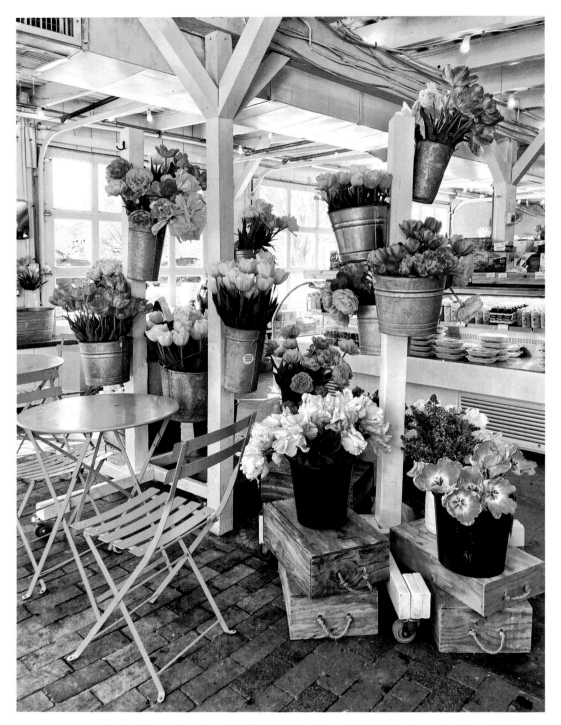

**ABOVE:** Amber Waves Farm's café is filled with buckets of colorful spring tulips from their flower fields. **OPPOSITE, CLOCKWISE FROM TOP LEFT:** Watermelons and sunflowers on display at Balsam Farm on Town Lane; Amber Waves Farm's rustic wagon cart on Main Street; a trio of classic Adirondack chairs and farm fields at Amber Waves Farm; fresh corn for sale at Balsam Farm

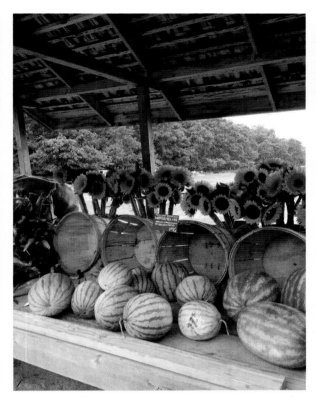
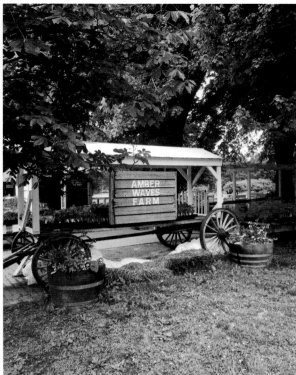

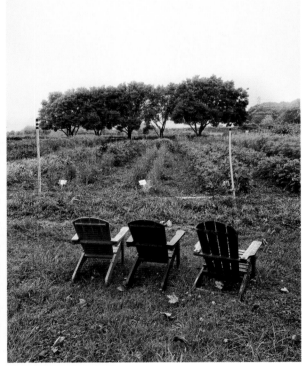

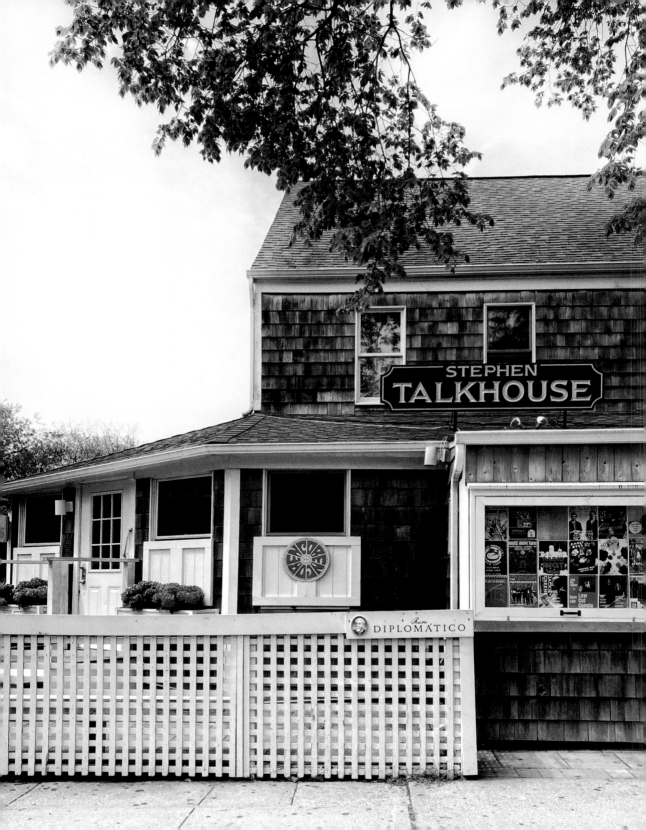

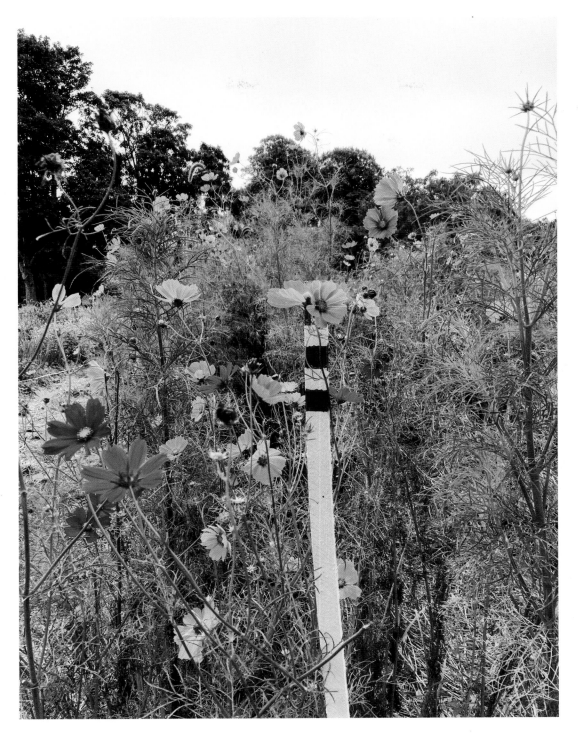

**OPPOSITE:** The iconic Stephen Talkhouse, an intimate music venue and bar (named after a famous nineteenth-century Montaukett Native American), is a favorite hangout on Main Street.
**ABOVE:** Pretty cosmos blooming in late August at Amber Waves Farm on Main Street

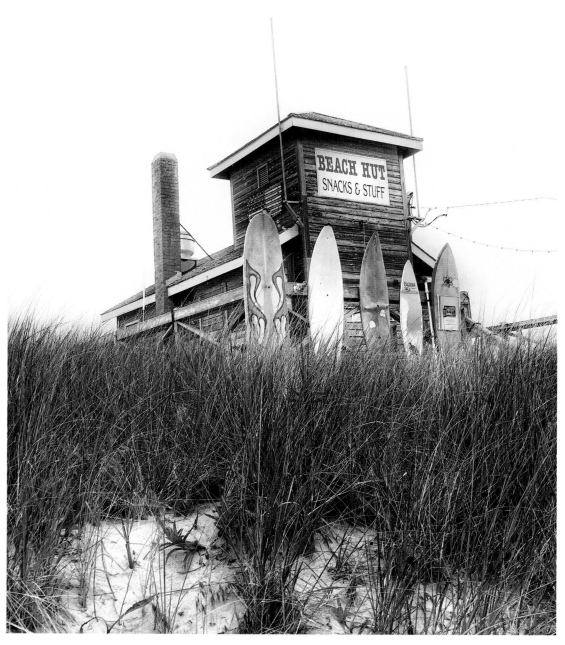

**ABOVE:** Atlantic Beach's funky Beach Hut is a go-to for summer snacks. **OPPOSITE, CLOCKWISE FROM TOP LEFT:** Early morning light and an empty lifeguard stand at Atlantic Beach; the historic Amagansett U.S. Life-Saving Station (ca. 1902) on Atlantic Avenue; rain-soaked surfboards at Atlantic Beach's Beach Hut; luminous late-day light at Indian Wells Beach

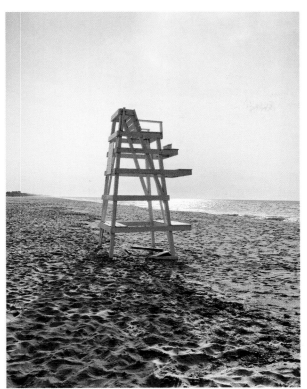
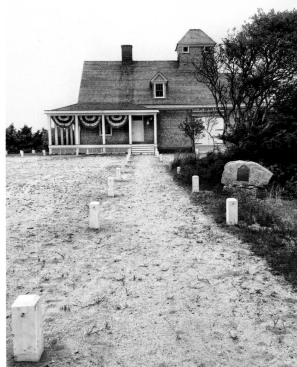
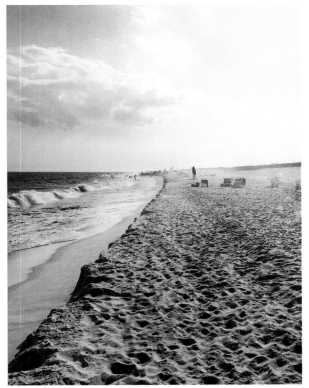

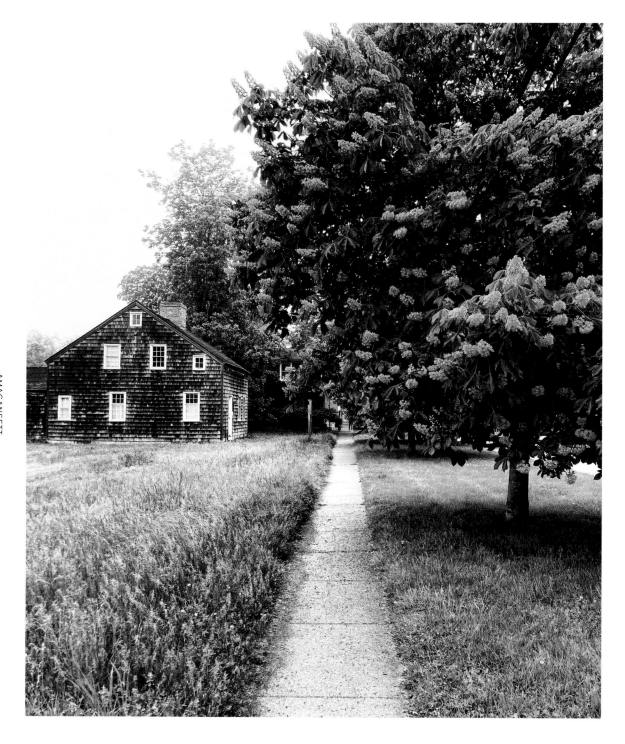

**ABOVE:** A postcard-pretty view of the Phebe Cottage (ca. 1805) and the beautiful horse chestnut trees blooming on Main Street

# My Favorite Walks and Drives

## AMAGANSETT

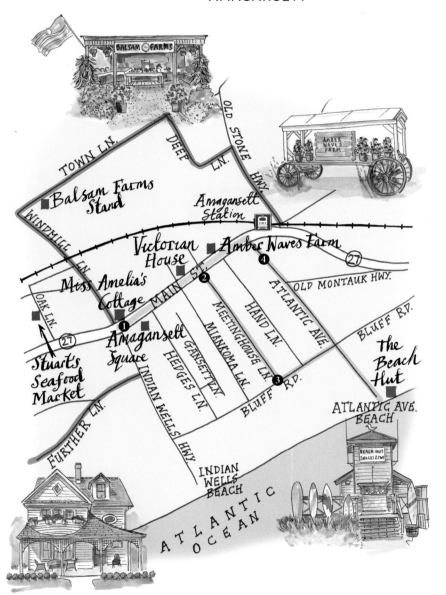

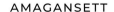

### WALKS:

**❶ Main Street**
Walking from Windmill Lane to Amber Waves Farm is the perfect way to see the charm of Amagansett.

**❷ Meeting House Lane**
The old, shingled houses that I love to shoot in every season are right off Main Street.

**❸ Bluff Road**
It's a scenic stroll past turn-of-the-century "cottages," and views of the Atlantic Ocean.

**❹ Atlantic Avenue**
A lovely tree-lined block leads to Atlantic Beach; the walk along the beach is perfect for viewing beachfront homes.

### DRIVE:

**☰ Windmill Lane Loop**
A short loop from the town center that takes you past Balsam Farms and along a country road and horse farms

# MONTAUK AND NAPEAGUE

Montauk, which means "Hilly Country," was named by the Algonquian-speaking Montaukett Indian tribe, but its location on the easternmost tip of Long Island has earned it another name: "The End." Though only about twelve miles east of East Hampton, its unpretentious vibe, rugged beauty, and casual surfer and fisherman lifestyle make it feel worlds away.

Montauk likes to consider itself the "anti-Hamptons." (Locals affectionately call it "a drinking village with a fishing problem.") In fact, taking a drive to Montauk from Amagansett has always felt like taking a mini vacation from the "Hamptons." As you leave the New England–like landscape behind, the road opens and the view radically changes. Instead of green lawns, giant shade trees, and farm stands, there are rolling sand dunes, low-lying shrubs, and roadside clam shacks.

But as many times as I've stopped along that flat stretch of Montauk Highway for a lobster roll at Lunch in Napeague, viewed the Art Barge (a converted World War II navy barge now used for art classes), driven along Old Montauk Highway (the slower but more scenic route to Montauk), watched sunsets with friends from the deck of the funky Montauket hotel, and strolled the grounds of the historic Montauk Point Lighthouse, I'd never taken many photos. Somehow Montauk's charm eluded me.

I had to challenge myself to look at these areas with fresh eyes. And what I found was a whole lot of charm—just a more rustic and laid-back kind: vintage silver trailers, quirky signs and colorful surfboards, old lobster traps on the bay in Lazy Point, and weathered beach shacks near Ditch Plains Beach. (Dubbed "surfer's paradise.") I now have a newfound appreciation for this modest fishing village that artists, writers, and luminaries such as Andy Warhol, Edward Albee, Paul Simon, Julianne Moore, Ralph Lauren, and Peter Beard have called home.

**OPPOSITE:** Unpretentious beach houses are nestled within the dunes by Ditch Plains Beach.

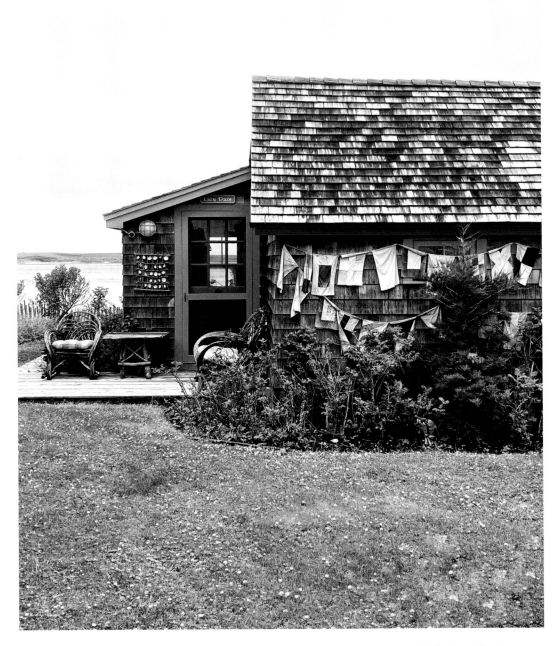

**ABOVE:** A picturesque, flag-festooned beach cottage on Lazy Point's Shore Road overlooking the Napeague Bay. **OPPOSITE, CLOCKWISE FROM TOP LEFT:** Scenes from Lazy Point in Napeague: Shore Road at dusk; the bay beach; an abandoned house on stilts still standing at the end of the private Mulford Lane; a tangle of buoys and nets on the bay beach

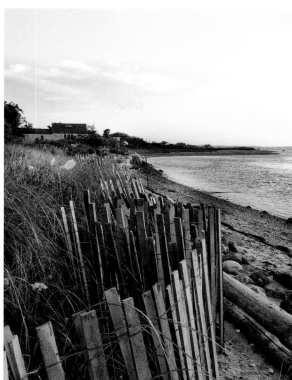
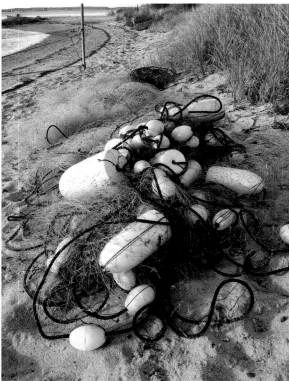
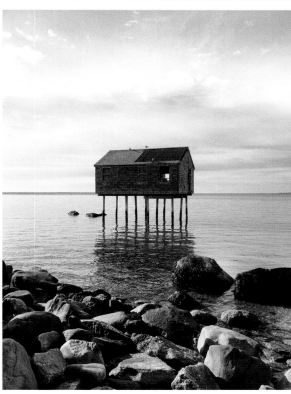

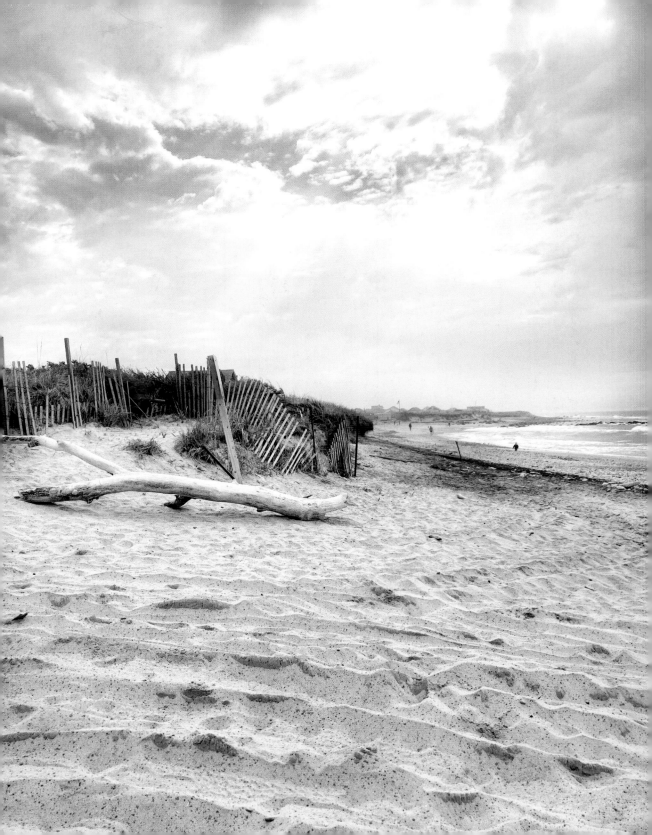

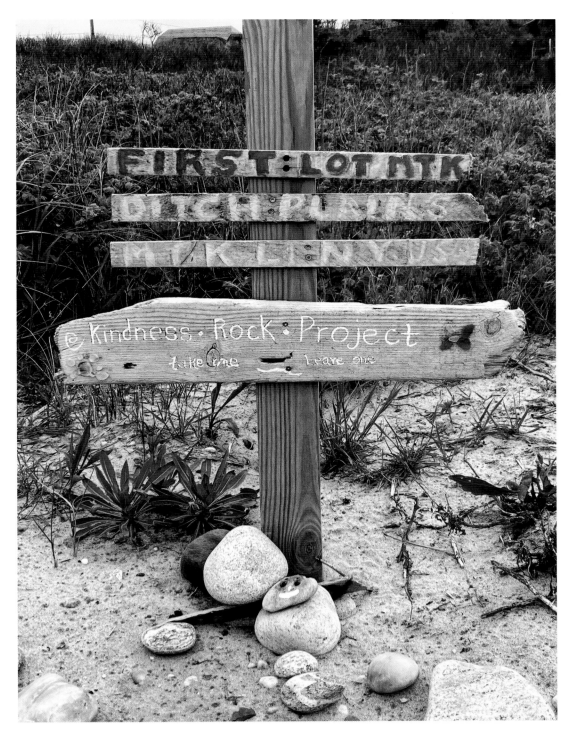

**OPPOSITE:** Driftwood and early morning light at Ditch Plains Beach, a surf mecca in Montauk
**ABOVE:** Funky hand-painted signs and the "Kindness Rock Project" at Ditch Plains Beach reflect Montauk's friendly and laid-back vibe.

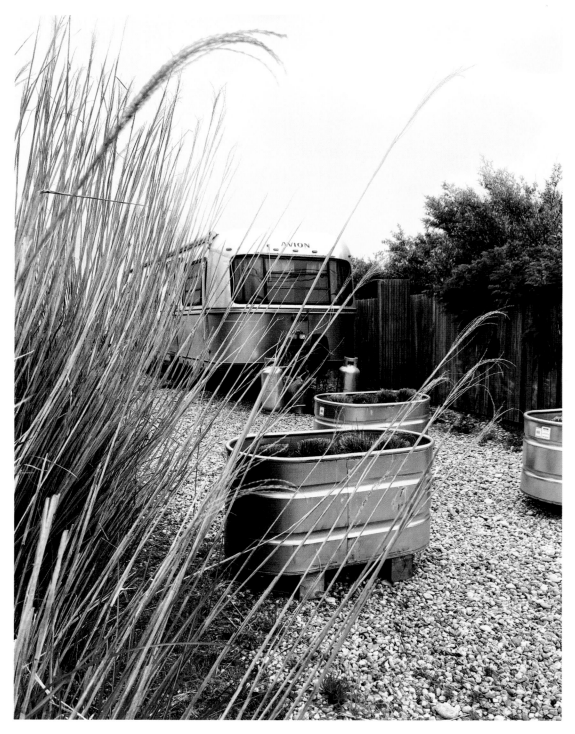

**ABOVE:** A sleek silver Avion trailer has set up house on Tuthill Road in Montauk.
**OPPOSITE:** Duryea's casual market and boutique on Tuthill Road is a favorite Montauk spot for coffee and shopping.

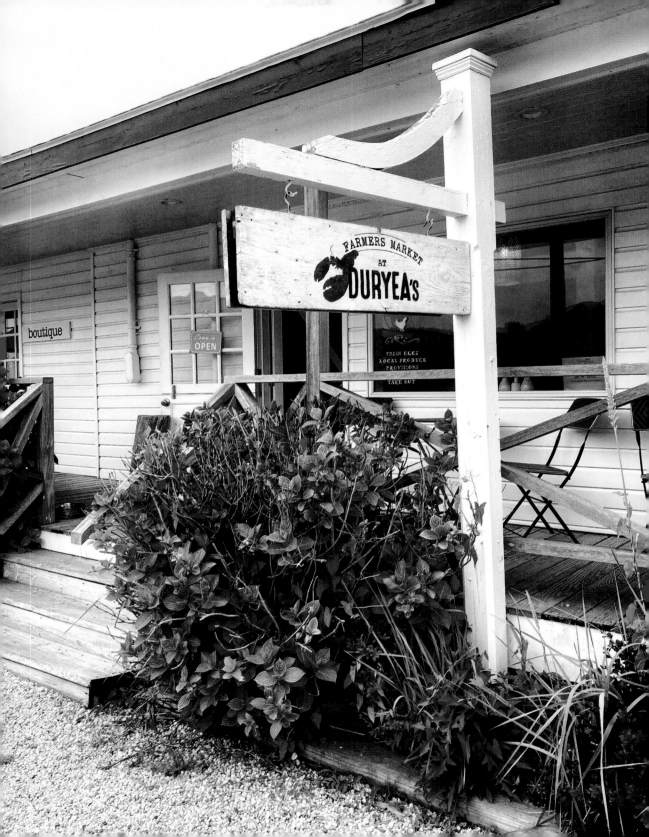

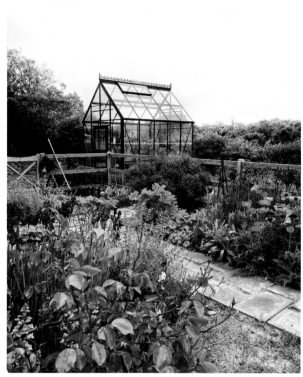

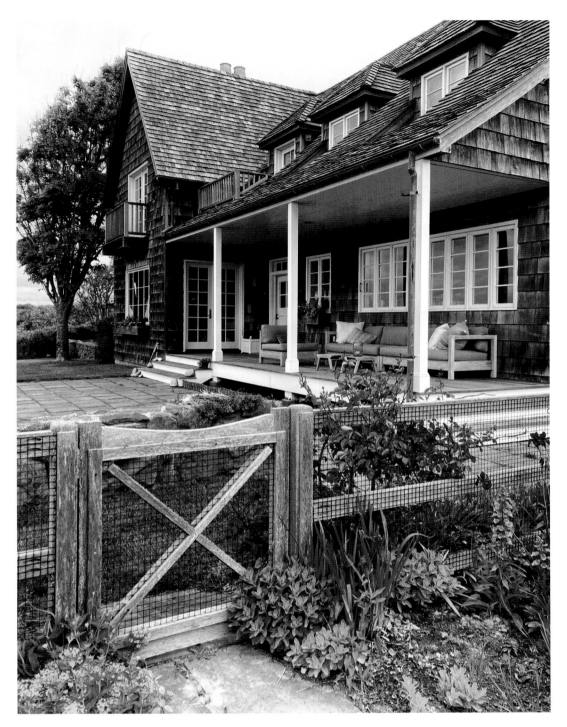

**OPPOSITE, CLOCKWISE FROM TOP LEFT:** A charming private garden and greenhouse near Ditch Plains; a quirky flower planter on Industrial Road in Montauk; a nautical-themed house address on Industrial Road; artist's studio in Montauk **ABOVE:** A traditional shingle house with a perfect porch for relaxing, near the Ditch Plain bluffs in Montauk

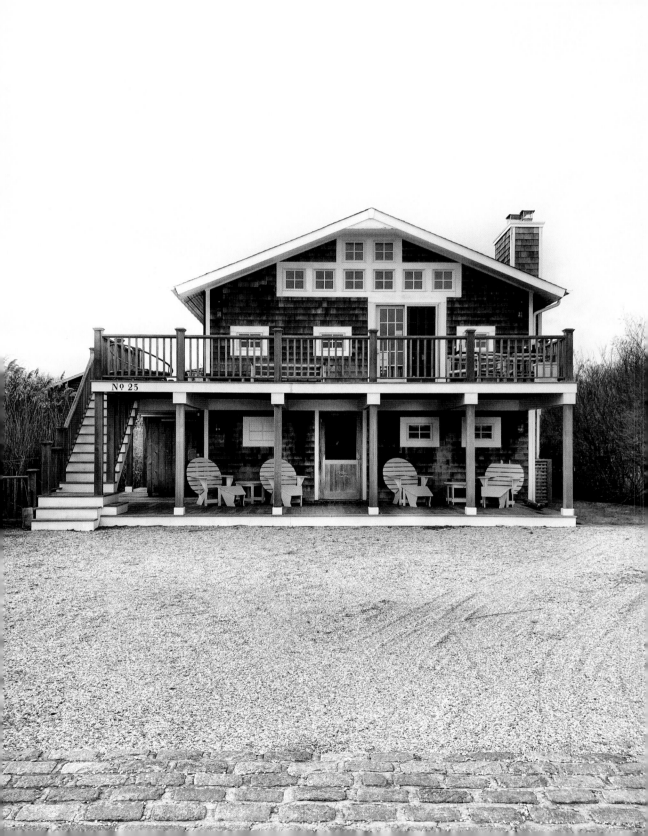

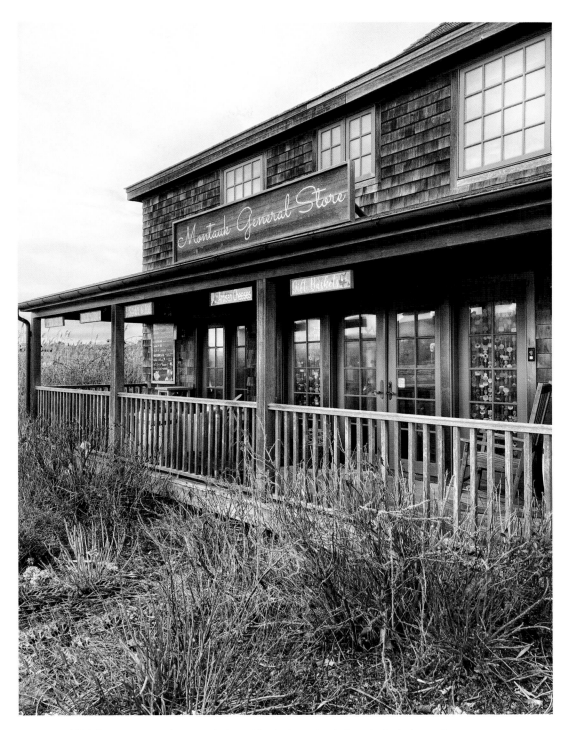

**OPPOSITE:** With its wraparound upper deck and funky turqoise Adirondack chairs on the lower level, this house on Otis Road (a block from Ditch Plains Beach) is summer porch perfection. **ABOVE:** A cold winter day at the Montauk General Store on Main Street, an old-school shop filled with an eclectic mix of goods

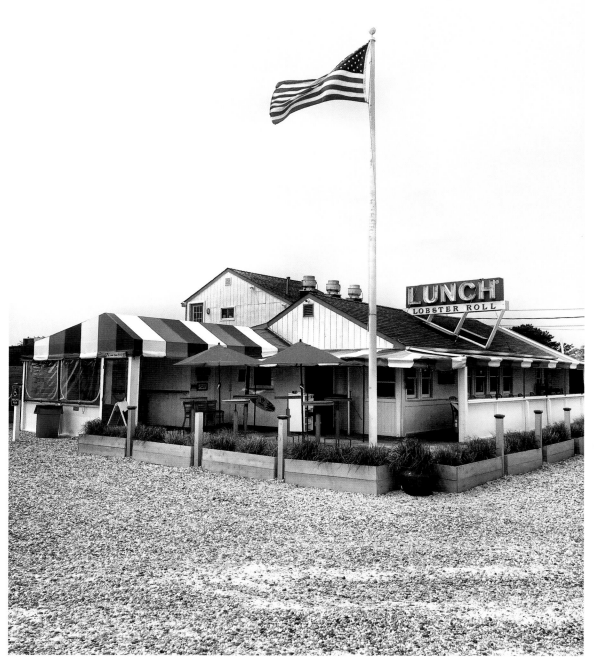

**ABOVE:** The iconic Lunch Lobster Roll restaurant's sign and its red-white-and-blue-striped awning make it an instantly recognizable Montauk Highway landmark in Napeague.
**OPPOSITE:** From Napeague Meadow Road, a dirt road with winter snow and beach grass leads to the Victor D'Amico Institute of Art, aka the Art Barge, in Napeague.

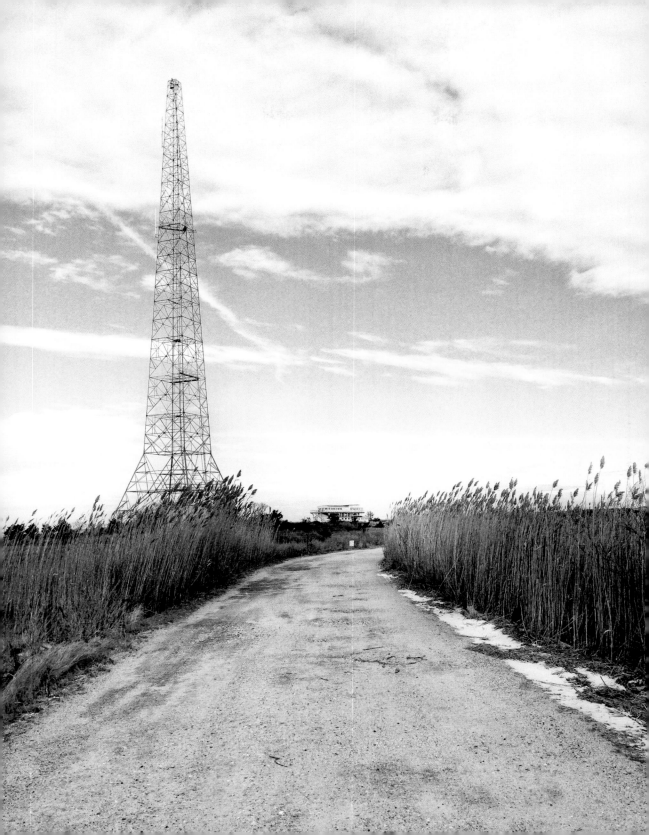

**ABOVE:** A colorful compound of tiny cottages and a surfboard on Tuthill Road in Montauk
**OPPOSITE, CLOCKWISE FROM TOP LEFT:** Duryea's "The End" sign (Montauk's nickname) in Fort Pond Bay; the Montauket hotel's colorful signs on Tuthill Road; a sailfish above the door leading to the Montauket's deck; surfboards displayed on Tuthill Road

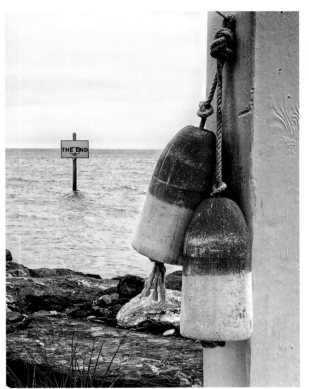

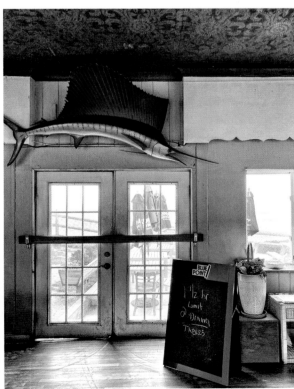

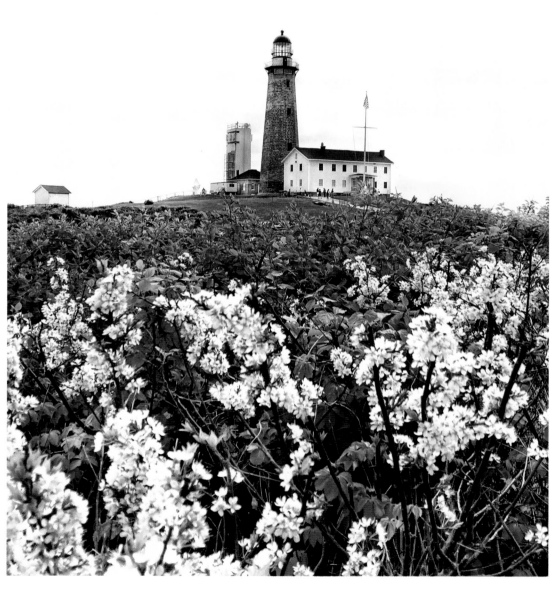

**ABOVE:** The historic Montauk Point Lighthouse and museum on the easternmost tip of Long Island was commissioned by President George Washington in 1796 and is the oldest lighthouse in New York State.

# My Favorite Walks and Drives

## MONTAUK AND NAPEAGUE

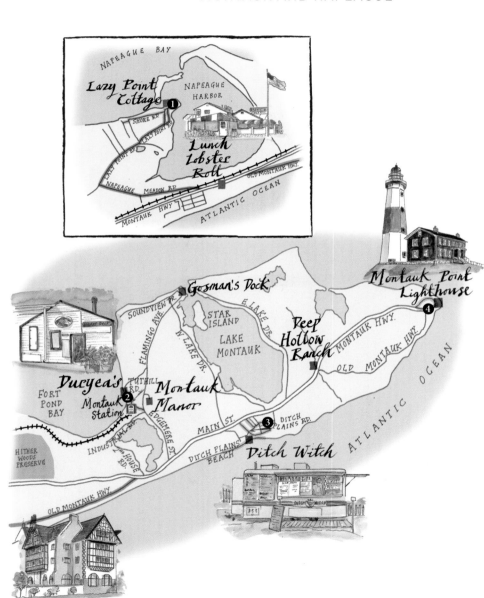

### WALK:

**❶ Shore Road and Lazy Point Beach**
Old fisherman shacks and cottages, plus a quiet scenic bay beach

### DRIVE:

**≡ Napeague Meadow Road to Lazy Point Road**
An open road and my favorite for natural beauty and a view of the Art Barge

## MONTAUK

### WALKS:

**❷ Tuthill Road**
Quintessential Montauk: surf shacks, trailers, Duryea's, and views of Fort Pond Bay

**❸ Ditch Plains Beach**
Great views of the rugged coastline, surfers, and modest beach houses

**❹ Montauk Point Lighthouse**
Scenic views of the Atlantic on all sides, plus a wonderful rocky beach

### DRIVE:

**≡ Old Montauk Highway**
Like a fun roller coaster ride (it's very hilly), with water views and the iconic Gurney's Resort

*In loving memory of my beautiful black Lab, Lucky (2015–2023)*
*My favorite walking companion*

# Acknowledgments

Like *Walk With Me: New York*, this book would never have seen the light of day without the encouragement of my loyal Instagram friends and followers. I am eternally grateful for their unwavering support.

I was thrilled to be reunited with my original dream team at Abrams: Rebecca Kaplan, editor extraordinaire; brilliant designer Darilyn Carnes; PR maven Gabby Fisher; and the entire Abrams team. Thank you for your support and enthusiasm for this book.

I am indebted to my agent, Kristin van Ogtrop, for her sage advice and for always having my back.

With the patience of a saint, genius illustrator Michael A. Hill created the most beautifully rendered maps for this book. Thank you for being a dream collaborator.

I am so lucky to have generous friends who unhesitatingly shared their time, talent, and expertise: I'm so grateful to Jenny Comita, who polished up my text; Brian Luckey, who polished up my photos; Susan Kirshenbaum, who was the best one-woman cheering section and Montauk tour guide anyone could have; and Rina Stone, whose original design concept lives on and who was always there when I needed her insightful advice.

A special thank-you to Eva and Walter Iooss, and Greg McCarthy and Peter Bickford, for graciously allowing me to photograph their beautiful homes for this book. And to Jenny Landey and Malcolm Carfrae, many thanks for sharing those contacts with me. You knew I would fall in love with their houses—and I did!

Thank you to my mother, for her boundless enthusiasm for this project and for encouraging me to "Keep chipping away at it!" whenever I was feeling overwhelmed. And to my family, whose constant support has meant the world to me.

And finally, my biggest thanks go to my husband, Shawn Young. It really comes in handy to be married to an award-winning art director when you're editing a book and need an expert opinion and a discerning eye. And there's no one whose opinion and eye I trust and value more than my husband's. So thank you, Shawn—I couldn't have done it without you!

# About the Author

**SUSAN KAUFMAN** (@skaufman4050) is a photographer, the author of *Walk With Me: New York*, the founding editor in chief of Time Inc.'s *People StyleWatch* magazine, and a former fashion director at Condé Nast Publications. Her photographs have appeared in numerous publications, including *Glamour*, *Hamptons Magazine*, *Country Living*, and Australian *Vogue*. She splits her time between her Greenwich Village apartment and her home in Amagansett, which she shares with her husband.

Editor: Rebecca Kaplan
Designer: Darilyn Lowe Carnes
Managing Editor: Lisa Silverman
Production Manager: Sarah Masterson Hally

Library of Congress Control Number: 2023949054

ISBN: 978-1-4197-7183-5
eISBN: 979-8-88707-209-8

Text copyright © 2024 Susan Kaufman
Photographs copyright © 2024 Susan Kaufman
Map illustrations © 2024 Michael A. Hill

Cover © 2024 Abrams

Printed and bound in United States
10 9 8 7 6 5 4 3 2 1

Abrams Image books are available at special discounts when purchased in
quantity for premiums and promotions as well as fundraising or educational
use. Special editions can also be created to specification. For details, contact
specialsales@abramsbooks.com or the address below.

Abrams Image® is a registered trademark of Harry N. Abrams, Inc.

**ABRAMS** The Art of Books
195 Broadway, New York, NY 10007
abramsbooks.com

**PAGE 1:** Cherry blossoms and a charming windmill on Sag Harbor's wharf
**PAGE 2:** Pink roses adorn a shack on East Hampton's Newtown Lane. **PAGE
3:** Privet and open gate on Sagg Main Street in Sagaponack **PAGE 4:** Pre-
Revolutionary house (ca. 1750) on Hedges Lane in Sagaponack **PAGE 6:** Jack's
Stir Brew's fishing-themed interior on Main Street in Amagansett **PAGE 174:**
Pretty flowers from Amber Waves Farm on the sunporch of my Amagansett
home. In 1944, painter Robert Motherwell used the sunporch as his studio.